The Calligrapher's
Handbook

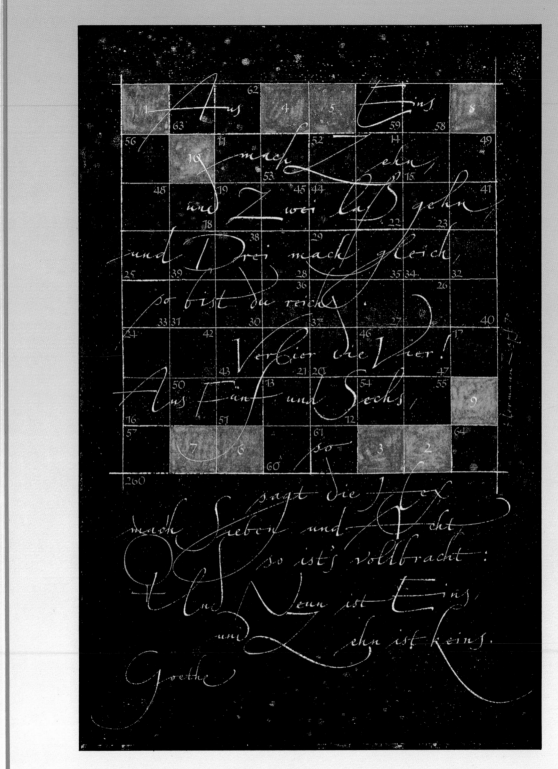

Aus Eins mach Zehn
und Zwei laß gehn,
und Drei mach gleich,
so bist du reich.
Verlier die Vier!
Aus Fünf und Sechs,
sagt die Hex,
mach Sieben und Acht,
so ist's vollbracht:
Und Neun ist Eins,
und Zehn ist keins.

Goethe

The Calligrapher's Handbook

GALLERY BOOKS
An imprint of W. H. Smith Publishers Inc.
·112 Madison Avenue
New York, New York 10016

A *Quill* BOOK

© Quill Publishing Limited 1985
First published in the United States in 1985 by
GALLERY BOOKS
An imprint of W. H. Smith Publishers Inc.
112 Madison Avenue
New York, New York 10016

ISBN 0 8317 1157 4

This edition reprinted 1987

This book was designed and produced by
Quill Publishing Limited
4-6 Blundell Street
London N7 9BH

Art director Nigel Osborne
Senior editor Patricia Webster
Designer Alex Arthur
Illustrator Fraser Newman
Design assistant Carol McCleeve
Special photography John Heseltine

Filmset by QV Typesetting Limited, London
Origination by Hong Kong Graphic Arts Service Centre Limited, Hong Kong
Printed by Leefung Asco Printers Limited, Hong Kong

Quill would like to extend special thanks to Nick Biddulph at the Lettering
Archive of the Central School of Art, Gunnlaugur SE Briem and Heather Child
for their invaluable co-operation and assistance.
Quill would also like to extend thanks to H. Band & Co; Brighton Polytechnic;
Camberwell School of Arts and Crafts; Falkiner Fine Paper;
Nicolete Gray; Lens Photography; Terry Paul; Alec Peever; Ravensbourne College of Art and Design;
Rexel Cumberland Graphics; Peter Thompson; John Woodcock.

CONTENTS

CALLIGRAPHY IN CONTEXT

Early writing

Written forms of language evolved slowly over hundreds of years, from pictures to the complex systems whereby abstract signs represent sounds of speech. The development of writing has two distinct stages of interest to calligraphers. The first stage is the mutation of pictorial symbols towards a standard alphabet form; once this basic tool of written communication has been established, the second stage of development concerns the way written alphabets vary from place to place and under different conditions. In western cultures the division between these two stages is marked by the most powerful period of the Roman Empire, when a standard alphabet had been achieved which was transmitted to the conquered lands of Europe and then developed by the influence of the early Christian church.

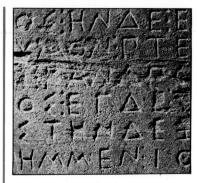

This writing (above), relating omens deriving from the flight of birds, is from Ephesus and dates from the sixth century BC.

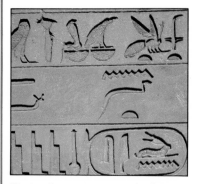

The best-known pictograms are Egyptian hieroglyphics (above). Assyrian script (left) is typical of the eighth and ninth centuries BC.

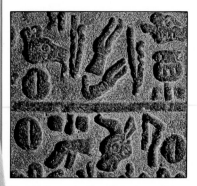

The Hittites, who founded a powerful civilization in Asia Minor between three and four thousand years ago, also used a form of hieroglyphics (above).

One of the oldest civilizations of which we have evidence is that of the Sumerians, who inhabited an area which now falls within the boundaries of modern Iraq. The earliest evidence of a writing system in Sumer is a limestone tablet showing several pictograms from the city of Kish, dating to about 3500 BC. The development of Egyptian civilization was concurrent with that of the Sumerians. From about 3000 BC the Egyptians used a form of picture writing known as hieroglyphics, meaning 'sacred, carved writing'. Within 200 years a script had been developed, known as hieratic script. A thousand years later a less formal script, known as demotic, was also in use. Hieratic evolved as a simplified version of hieroglyphics, whereas demotic was a cursive, practical hand. The Egyptians, like the Sumerians, had developed their writing through pictograms to ideograms and then to phonograms. By 1500 BC they had established an alphabet of 24 consonantal symbols, although this was never fully detached from the hieroglyphics and ideograms; the various forms were written side by side.

Pictorial hieroglyphics (below) were retained in ancient Egypt long after a linear script had been developed. Skill and scholarship were needed to master the written language and scribes took pride in the careful design of a wall inscription or long papyrus roll. Each sign represented a word but hieroglyphics also employed what is known as the rebus device: two symbols combined according to the sounds they represent to reproduce a separate, two-syllable word.

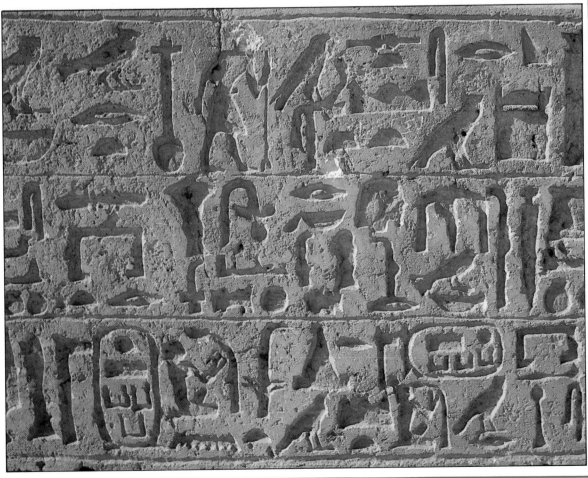

The oldest known alphabetical inscription of the Phoenicians dates from 1000 BC. It is not known precisely how their system evolved, but there are ancestral links with Sumerian pictography and the cuneiform symbols taken over from the Babylonians. There were a number of different Phoenician settlements and local varieties of written forms. However, by 1000 BC there was at least one alphabet system in existence with only 30 symbols, each sign representing a single consonantal sound. These symbols were entirely abstract, not suggestive of pictures or associative ideograms. Phoenician culture survived a period under the Assyrians and the Phoenician alphabet was passed on to the Greeks in the form of 24 consonantal signs. It was also influential as the basis of Persian writing and the later development of Arabic scripts. The Greeks adopted the Phoenician alphabet, some time before 850 BC. There had been an earlier form of Greek writing, originating from Cretan scripts of 2500 BC and later. This, however, had disappeared by 1200 BC, as far as can be judged from surviving inscriptions, and it appears that by the time they started developing their own alphabet on the Phoenician model the Greeks were largely unaware of this earlier script.

In Phoenician characters (below), which formed the basis of the Greek and Roman alphabets, both the origin and subsequent mutation of the symbol can sometimes be seen. The second letter in the sequence is aleph, the V-shape representing the head of an ox, the cross-bar its horns. But the basis of the standard form of the Roman capital A is also visible.

Letterforms from a Greek inscription of the fourth century BC (above), carved in white marble, show clearly how the forms of individual letters had evolved distinctively.

Etruscan letters (above) relate closely to Greek forms. The Etruscans occupied Roman territory for almost four centuries, but development of the formal Roman alphabet occurred after this period.

The Romans adopted certain characters from the Greek alphabet almost without modification (A B H I K M N O X T Y Z). They remodelled others to suit their own language (C D G L P R S) and revived three symbols discarded by the Greeks (F Q V). By the dawn of the Christian era, the Romans had established not only this formal alphabet of a fixed number of signs, but also several different ways of writing it. Roman square capitals, the *quadrata*, are the elegant, formal letters seen on monumental inscriptions in stone; they were also drawn with brush and pen, but the fine, serifed forms of the inscriptional writing owe much to the chisel. A less formal, more quickly written version was Rustic capitals; compressed, vertically elongated characters with softer lines. This became the main book hand of the Romans and was more economical than the squared *quadrata*. A cursive majuscule script evolved from the formal capitals and several variations of informal cursive script came into being. These were all standard forms within the Roman Empire by 146 BC and Greek was retained as the language of scholarship, and for daily use in the ordinary communications of Greek-speaking settlements.

As the Roman Empire proceeded with its vast business of government and trade, there were many administrative centres employing professional scribes and so there was much demand for the skills of writing and carving letters. A high proportion of the Roman population was literate and writing was an important method of communication at all levels. Examples of public notices painted on walls can be found in the ruins of Pompeii. The Roman alphabet of the first century AD is the basis of the modern western alphabet and has been altered only by the addition of the characters J V and W, which were originally represented by I and U. These were medieval amendments. The most crucial influence upon the further development of writing, but concerned entirely with style and materials, was the rise of Christianity. This became the official religion of the Roman empire in 313 AD. In Egypt, which had become a province of Rome in 30 BC, Christian influence closed schools and temples and caused the final demise of the hieroglyphic heritage. While the influence of the Phoenician alphabet elsewhere developed towards modern Hebrew and Islamic script, missionaries spread the Roman alphabet across Europe.

Roman sculpted capitals from the base of a piece of religious statuary. The prevalence of Roman lettering on a wide range of artefacts testifies to a relatively literate, organized society.

The Arch of Titus (below), which stands outside the Forum in Rome, is typical of the monuments the Romans loved to erect. They planned the inscriptions with great care, suiting the size and spacing of the words to their importance and meaning. Later Roman inscriptions used Rustic script. This carved inscription (opposite page, 4) is from the catacombs of Priscilla in Rome, and uses Rustic capitals. It is typical of the period.

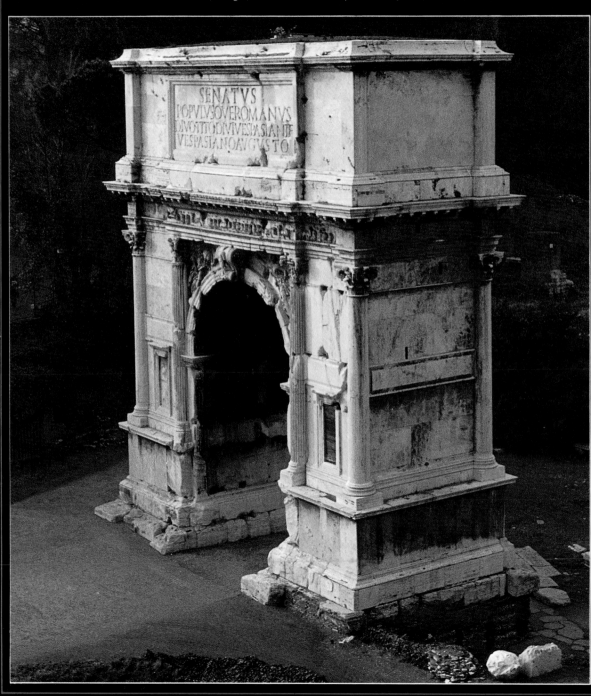

Roman coins, made from Greek silver, featured low relief and inscriptions (1 and 2). Inscriptions were also common on ceremonial artefacts, like this silver bowl (3), dating from the fourth century AD.

The earliest known Christian manuscript (5) is only a fragment, but is still quite legible. It shows a section from an unknown gospel, and was written on papyrus in the first century AD.

MAXIME
VIVAS
INDEO

Arabic manuscripts were often highly decorated. This piece (above), taken from the Annals of Selim II (1580), is highlighted in red and gold.

The Eastern tradition

Eastern calligraphy is fundamentally bound to religious and philosophical thought; writing has a mystical significance not widely recognized in western cultures and the history of the art of writing is entwined with that of other art forms. The brush is the primary instrument of oriental calligraphy and text is written vertically from right to left. The movement and disposition of the whole body contribute crucially to the calligrapher's skill. A page of written Chinese or Japanese has a rich and varied texture because of the many hundreds of separate characters that can be used. Each is written as if it were fitted to an imaginary grid, which means that scale and proportion are regulated. There is an important value to the articulation of each brush stroke, the way the character is composed and the fluidity of linear variation. In China, calligraphy is inseparable from painting. Hand-painted characters are used as decoration in every home, with or without accompanying pictures; the streets of towns and villages are covered in notices, banners and hand-painted signs. Handwriting is accepted as a notable form of self-expression and more than this, fine handwriting is appreciated as a mark of respect to those to whom it is addressed.

بالای یکی این حویج بنهد و دوم را بالای آن نهاده یك راچهاریخ کرت بخوردهد بعده کابجی

Eastern writing is generally more cursive than European alphabets, and the fluent letterforms and diacritical marks lend themselves to artistic display. This detail from an ancient Indian manuscript (above) shows how a simple line of text can become a thing of great visual beauty.

The alphabet of Arabic languages consists of 29 characters, mainly representing consonantal sounds. It has the same original roots as the Roman alphabet, but over the centuries has evolved quite differently and there are many variations of Islamic scripts. The alphabet consists of groups of characters sharing a basic consonantal symbol, to which diacritical signs are added that express vowel sounds and specifics of pronunciation. A letter may alter slightly in character according to its position in a word — as the first or last letter, for example — and whether it is joined or standing alone. Islamic calligraphy is itself held in very high esteem; the Qur'an explains that writing is a gift bestowed by God. Since an important part of the religious observance involves memorizing sacred texts, Islamic artists are able to exploit the abstract qualities of writing — the pattern and texture of words — knowing that their readers will still understand the text. Any object or material that can be carved, modelled or painted has at some time in the East been decorated with writing or constructed in the forms of letters.

A comparison of uncials: Roman uncials of the fourth to sixth centuries (above, left column) and half-uncials from the fifth and sixth centuries (above, right column); an extract from a sixth-century Latin gospel, showing typically even and undecorated lettering (above right); tenth-century Carolingian minuscules (below).

The development of minuscule scripts

By the fourth century AD the Romans had developed a new script, the uncial, which became the main book hand of Roman and early Christian writings, continuing until the eighth century. The term uncial was first applied to the script in the eighteenth century and derives from *uncia* meaning 'one inch'. The new script was a modification of square capitals, possibly based on cursive majuscule forms used in business records and contracts. The letters were still contained within a fixed height, like the capitals. The characters A D E H and M, however, were rounded, D and H having brief rising strokes like the ascenders of later minuscule forms. The uncial was then followed by the half-uncial. Here, for the first time, certain letters broke through

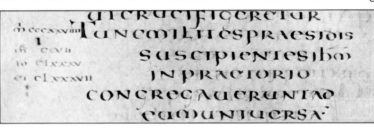

the writing lines with noticeable ascenders and descenders. This was a formalization of cursive styles that had developed in day-to-day use and were modified as writing became speedier. Half-uncial script was secondary to uncial and both were later replaced by formal minuscule alphabets. All Roman letterforms show the influence of the square-edged pen, which produced the characteristic graduation of thick and thin strokes that echoed the forms inscribed with a chisel.

At the end of the eighth century, a general renaissance of European scholarship and culture was organized under the patronage of Charlemagne, who governed a vast area of Europe. Charlemagne commissioned Alcuin of York to revise and standardize the variations of minuscule scripts that had appeared. In so doing, he referred back to the original forms of Roman alphabets — square Rustic capitals, uncials and half-uncials. Alcuin's finest achievement was the development of a formal minuscule script for use as a standard book hand. This has become known as the Carolingian minuscule, after its instigator, Charlemagne. It was widely adopted throughout the Holy Roman Empire and beyond and by the tenth century was in general use in England. The development of Carolingian minuscules was the most important development in the history of writing since the standardization of the Roman alphabet. From this point, all the elements of modern writing were in place; modifications since that time have been essentially practical or fashionable, not basically structural.

A striking piece of Japanese calligraphy
(below). These few characters are an
eloquent demonstration of the close link
that persists between writing and art in
the East. They were executed with a
brush by Koyama Tenshu.

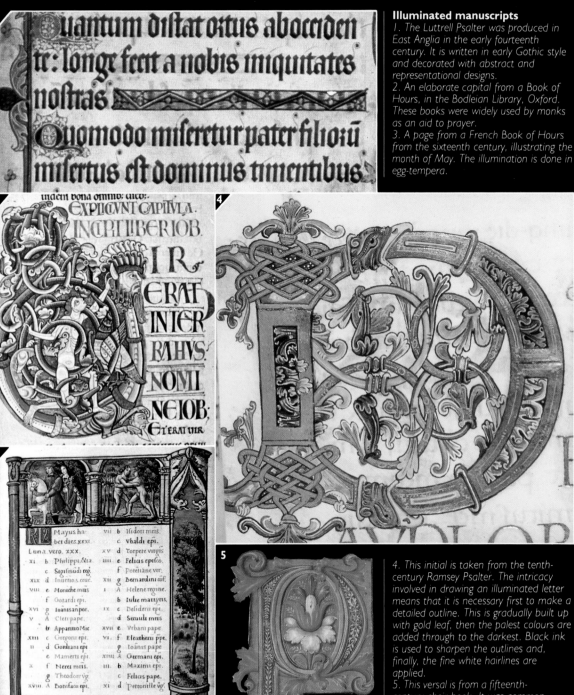

Illuminated manuscripts
1. The Luttrell Psalter was produced in East Anglia in the early fourteenth century. It is written in early Gothic style and decorated with abstract and representational designs.
2. An elaborate capital from a Book of Hours, in the Bodleian Library, Oxford. These books were widely used by monks as an aid to prayer.
3. A page from a French Book of Hours from the sixteenth century, illustrating the month of May. The illumination is done in egg-tempera.

4. This initial is taken from the tenth-century Ramsey Psalter. The intricacy involved in drawing an illuminated letter means that it is necessary first to make a detailed outline. This is gradually built up with gold leaf, then the palest colours are added through to the darkest. Black ink is used to sharpen the outlines and, finally, the fine white hairlines are applied.
5. This versal is from a fifteenth-century choir book. It was common practice to rule the staves in red and write the notes and words in black; versal illumination and Rotunda script were also popular.

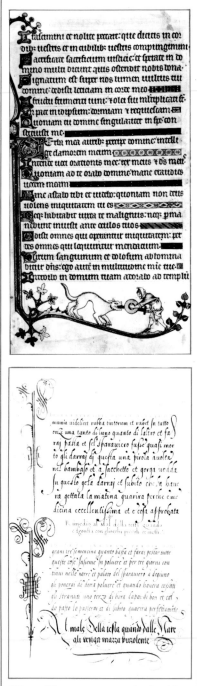

This twelfth-century manuscript (top) is written in Textura; the patterned line endings are typical of this period. The elegant cancelleresca or chancery script (above) was characterized by flourished ascenders and descenders.

From Gothic to Gill

Gothic was a term applied to the products of the late medieval period by the Renaissance scholars, who thought the cultural style of that period so outrageous that they named it after the barbarian Goths. The development of minuscule scripts in Italy during that period also tended towards compression and angular forms, but they never took on the rigid vertical stress typical of northern European forms. In Italy, the minuscule retained a more rounded character and was known as Rotunda, also indentified as *littera moderna*. This style was used in handwritten and printed works until the late Renaissance period. In fifteenth-century Italy, new styles of writing were developed, which became known as Humanist scripts because they were associated with scholarship and science. Around 1400 the Florentine scribe Poggio Bacciolini (1380-1459) returned to the original form of Carolingian minuscules as the source of a new book hand, an alternative to the Rotunda script. This was termed *littera antiqua* in acknowledgement of its origins, which were older than those of the *moderna*. Also in the early fifteenth century, the scribe Niccolo Niccoli (1363-1437) derived an angular, cursive hand from the informal Gothic cursive. This was the basis of Italic script. Both men returned to classical Roman forms for their capital letters, and Niccoli's were given a slight slant, in keeping with the tilted stress he also used for his minuscule script.

The revival of the skills of writing and illumination in the medieval pattern was instigated in the late nineteenth century by the designer William Morris (1834-1896). He led a renewal of interest in hand-crafted products, taking particular interest in the forms and standards of pre-Renaissance workmanship. His own designs for wallpaper, textiles and furniture influenced public taste and had considerable impact on the aims and methods of contemporary artists and craftsmen. In 1890 Morris founded the Kelmscott Press and began to produce printed books, in which every feature of the design and decoration was informed by much earlier traditions. Against this background of medievalism, by coincidence and also by sheer hard work, one man, Edward Johnston (1872-1944), became largely responsible for the bases of modern calligraphy. He studied at the British Museum, copying old manuscripts, learning the form and technique of medieval scribes and improving his own skills. He was the first to teach the craft of pen lettering and his classes were an enormous success. Among his students in those early years were young talents such as Eric Gill (1852-1940) and Noel Rooke (1851-1953), but also more established figures — notably T. J. Cobden Sanderson (1840-1922), a bookbinder and typographer who had worked with William Morris. The typeface in which this book has been set was designed by Eric Gill.

Modern applications of calligraphy
This etching by Karlgeorg Hoefer (above left) demonstrates liveliness in form and design. Hoefer is also noted for his skill in brushwork. The coat of arms of Puerto Rico (above) is part of a presentation panel by Donald Jackson. Both raised and flat gold have been used in the crown. The raised areas are burnished gold and the flat is powdered gold. Platinum has been used in the lamb and a quill was the writing tool. Executed in brown ink and watercolour on hand-made paper, this book (left) was produced by the calligrapher Hella Basu.

PEN, INK AND PAPER

The basic requirements of the calligrapher are simple and inexpensive although, as with any art form, more elaborate effects may call for more adventurous tools, media and surfaces. Early writers employed natural materials — reeds and feathers for nibs, animal hair for brushes, reeds and calfskin for a surface — but the modern calligrapher has access to an immense range of man-made equipment, from fountain pens to felt-tips and from fine, white paper to canvas.

Reed pens

Probably the earliest form of nibbed writing instrument, reed pens were widely used by early writers in the Middle East, where hollow-centred, sturdy reeds are plentiful. Modern calligraphers still enjoy their bold effect, and they can be made easily and cheaply. Garden canes are a suitable substitute if reeds are hard to find. Cut the reed down to a length of about 8in (20cm) and slice one end at an oblique angle; shave away the soft pith from the centre until the outer surface, which will form the nib, is fine and hard; trim the edges of the cut tip to form the shoulders of the nib, make a vertical slit up the centre to ensure a steady flow of ink and, finally, cut cleanly across the tip at the desired writing angle.

Reed nibs can be cut to a broader width than quill nibs, so they are ideal for large writing, giving a pleasing contrast between the thick and thin strokes (below). A selection of nibs can be cut to suit different tasks (top). When making the central slit (above), ensure that it does not run too far up the nib.

Quill pens

The flexibility and fineness of a quill pen ensure its continued use, especially for work on vellum and other traditional surfaces. The familiar image of an elaborate plume is, however, somewhat impractical: the basic quill pen is stripped of its barbs and shortened to 7–8in (18–20cm) for ease of handling. Primary flight feathers of swans, geese and turkeys are ideal, and smaller birds like ducks and crows provide fine shafts for delicate work. Before a quill is cut, it must be dried to strip it of its natural oils. Various heating techniques can be used — the gentler, the better, since heating makes the quill brittle. Ideally, leave the quill to dry out naturally — although this can take as much as a year. Ready-cut quills are available, but it is always better to trim each nib individually, so that the slant of the nib reflects the angle at which the user prefers to write. Quill nibs need frequent retrimming to maintain a fine line; always cut back the shoulders as well as the tip, to maintain flexibility. The curve of the pen is important, too — left-handed writers should choose a feather from the right wing of the bird, right-handers one from the left. Then the natural curve of the shaft will sit neatly in the hand, instead of curling awkwardly outwards.

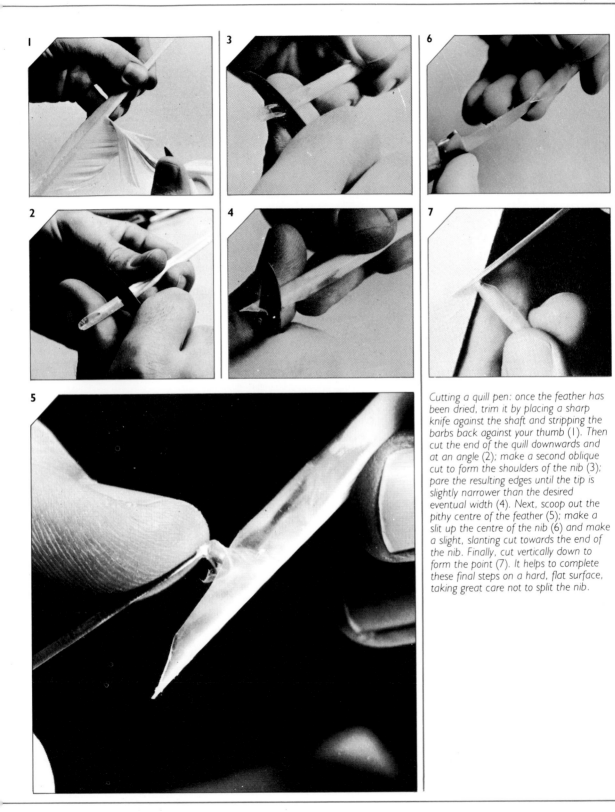

Cutting a quill pen: once the feather has been dried, trim it by placing a sharp knife against the shaft and stripping the barbs back against your thumb (1). Then cut the end of the quill downwards and at an angle (2); make a second oblique cut to form the shoulders of the nib (3); pare the resulting edges until the tip is slightly narrower than the desired eventual width (4). Next, scoop out the pithy centre of the feather (5); make a slit up the centre of the nib (6) and make a slight, slanting cut towards the end of the nib. Finally, cut vertically down to form the point (7). It helps to complete these final steps on a hard, flat surface, taking great care not to split the nib.

The transition from quills to metal pens led to the development of new inks, too. Early inks were made from a variety of pigments, such as lamp black suspended in gum and water or iron salt and oak gall; some of these have kept their colour well, but they corroded the new metal nibs, so aniline dyes were introduced as substitute pigments. The range of ready-made inks available today is immense, and it is worth trying out various types for different tasks. The basic requirements are that the ink should flow freely but not spread, and that it should be quick-drying and stable when dry. Waterproof inks are inadvisable, since they are fibrous and tend to clog the nib.

Metal pens (right) have a wider range of nib designs than reed or quill pens. The earliest metal nibs known were made by the Romans in bronze, since when numerous attempts have been made to perfect a more durable, flexible version. Early nineteenth-century steel nibs were scratchy and insensitive but modern nibs are very similar in design. A vast range of shapes and sizes is now available. Nibs and holders are sold either separately or as a unit. To avoid metal deterioration, nibs are coated with a fine lacquer, which must be removed by gentle scraping or brief exposure to a flame, to ensure a steady flow of ink. The modern fountain pen is a convenient tool for small-scale work, with a regular flow of ink, and many manufacturers now offer a calligraphy pen with a range of nibs (far right). Many nibs come with slip-on reservoirs to ensure a steady ink flow.

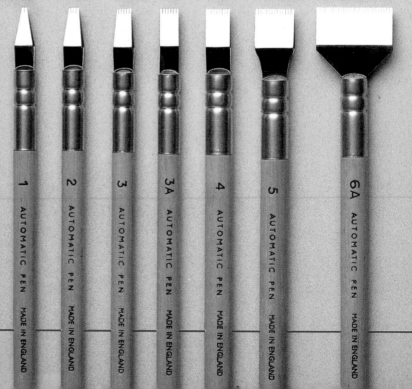

1 AUTOMATIC PEN MADE IN ENGLAND
2 AUTOMATIC PEN MADE IN ENGLAND
3 AUTOMATIC PEN MADE IN ENGLAND
3A AUTOMATIC PEN MADE IN ENGLAND
4 AUTOMATIC PEN MADE IN ENGLAND
5 AUTOMATIC PEN MADE IN ENGLAND
6A AUTOMATIC PEN MADE IN ENGLAND

Round hand pens are very versatile tools: nibs may be square-cut (2) or oblique (3) for left-handers. Script pens (4) make no variation between strokes and are used for monoline or unshaded lettering. Specialist nibs include five-line pens (5), useful for musical staves; scroll pens (6), which give a double-lined shadow effect; copperplate pens (7), very fine and responsive; poster pens (8), which produce striking contrasts between strokes. A range of advanced nibs for decorative lettering (1) is also available.

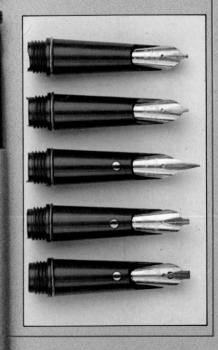

Other tools available to the calligrapher include felt-tips and fibre-tips. Both are vulnerable to wear and tear, tending to lose their shape; also, the ink of some felt-tips tends to spread. Nonetheless,

they are useful for practice, roughs and outlines. Brush-stroke effects can be achieved with felt-tips or with a broad-nibbed pen (above).

The suitability of a surface for calligraphy depends on the tools used — engraving glass or chiselling stone are applications of the art that can be most effective. Traditionally, scribes used vellum or parchment. Vellum has a velvety nap and a slightly springy surface, ideal for formal work. Even today it is handmade, from calfskin or goatskin. The skin is limed, scraped, stretched, dried and shaved. Vellum may be light in tone, brownish or mottled; some variation in tone can add distinction to the finished piece. Sheets of vellum are expensive but offcuts are sold for practice. Errors can be removed by scraping with a sharp knife, then finishing with an eraser and pounce. Parchment is made from sheepskin and is tougher and hornier than vellum; it is still used for tasks requiring a rougher surface.

The word 'paper' derives from the Egyptian papyrus, a fibrous reed that was cut into strips, latticed and hammered to form a writing surface. Some papers are still made from vegetable fibres — especially cotton, linen and hemp — which are pulped, poured into paper-making trays, drained and pressed. Cheaper papers are made from wood pulp; these are

Papers are manufactured with a variety of surface finishes. The texture of the paper affects the smoothness of the pen strokes made on it. A close-grained paper allows the most fluid stroke but interestingly textured effects can be achieved on Rough or Cold-pressed paper, as the fibres break and speckle the strokes. Three examples of the same strokes on different papers (above) show graduated textural variations.

Essential components of the calligrapher's toolkit include a sturdy wooden rule — preferably with a metal edge, for use as a guide when cutting — a T-square and a clean, soft eraser. Pencils are useful for practice, layout and guidelines. Ruling on most papers requires a clear, erasable line, provided by an H or HB pencil; vellum and other fine surfaces call for a lighter, finer tool such as a 6H or 7H. Double pencils are useful for understanding the structure of letterforms. Strapping together two pencils of different colours or weights (for example, an H and a carpenter's pencil) accentuates the effect of the writing angle and demonstrates the variations in letterform produced by different nib-widths. The same form made by a broad pen (below left, bottom) can be made with a double pencil (below left, top), which clearly illustrates the formation of the stroke. Practice letters made with a double pencil (left) give a useful introduction to construction and spacing.

less durable and may tear or buckle. Paper manufacture was introduced to western Europe in the fourteenth century but was not automated until the nineteenth. A wide range of papers are now produced in different weights and with surfaces graded as Hot-pressed, Cold-pressed or Rough. Hot-pressed papers are smooth and close-grained, and less absorbent than the other grades. Finish is important, too: a rough, fibrous surface will obstruct the nib while too heavy a coating or glaze will resist ink. Papers suitable for practice and roughs include a draughts-man's layout pad, flimsy but stable; bond paper, smooth and white; correspondence papers, which are available in a wide range of colours and finishes; the matt side of brown wrapping paper or even unwaxed shelf paper. For finished work, a good quality cartridge paper can be quite adequate but handmade papers are generally preferred. These are expensive, of limited size and may not be quite square, which must be taken into account when ruling the page. Machine-made rag papers often imitate handmade papers, and can also offer distinctive qualities of their own.

Chinese stick ink (below right) is a versatile medium. The scribe controls the density and texture of the ink, rubbing down small quantities with distilled water in a small, sloping block (below left). Mixing colour or gum can be added to alter the colour or texture of the ink. Watercolour or gouache can also be used with pen or brush, diluted to a milky consistency with water.

Brushes (above right) can be used to feed ink to a pen, to apply size or colour or, instead of a pen, to form letters. Sable brushes are ideal for feeding and colour-work, in varying widths depending on the task. Chinese bamboo brushes with hair tips make good lettering brushes, with an interesting variation in stroke. Specialist brushes (right), such as duck down or peacock feather, are available for work requiring a soft effect, such as Chinese or arabic lettering. The flexibility of a brush tends to produce more evenly graded letterforms than are possible with a pen, and gives a characteristic broad, soft effect.

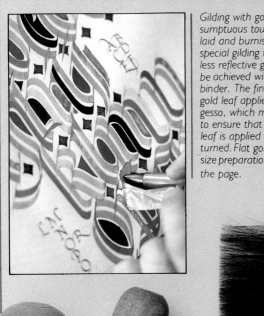

Gilding with gold leaf (left) adds a sumptuous touch to lettering. The leaf is laid and burnished on the page with special gilding tools (right and below). A less reflective gold for backgrounds can be achieved with powdered gold in a gum binder. The finest gilding method is raised gold leaf applied to a small cushion of gesso, which must be carefully prepared to ensure that it will not crack when the leaf is applied or when the page is turned. Flat gold can also be laid on a size preparation, drawn or painted on the page.

FORMS AND FLOURISHES

The written forms of most languages in the western world are constructed from the 26-letter alphabet based on letterforms perfected by the Romans. These letters can be written in many different ways — in capitals or script, in hands that are rounded, slanted or angular — but all stem from the Roman model. Whatever the style, every letter has an essential form, that makes it distinct from other letters and readily recognizable. This basic letterform structure must exist whether the letter is written, carved, painted or modelled and in however plain or elaborate a form, for it to function effectively as a component of language. The skills involved in calligraphy are different to those of ordinary writing: handwriting styles aim to promote speed whilst retaining legibility, whereas the prime aim of calligraphy is consistent structural beauty.

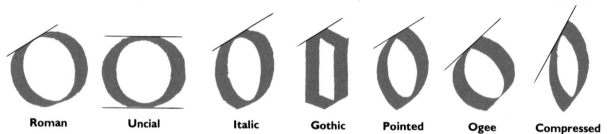

Roman **Uncial** **Italic** **Gothic** **Pointed** **Ogee** **Compressed**

The special interest of formal penmanship is the effect of the tool on the alphabet. The edged pen automatically produces thick, thin and graduated strokes that can be organized in a fixed relation to every letter of the alphabet. This is achieved through regulating the direction and angle of the strokes used in constructing the forms. The pleasure of the craft is that the action of the pen provides a logical structure to the rhythm of writing but does not restrict the forms that can be made.

In normal handwriting, the pen stays on the paper and is pushed and pulled in any way that quickly describes the necessary features of letters. One of the basic precepts of calligraphy is that the pen is always drawn or pulled across the surface, never pushed against the grain. This rule requires that the pen be frequently lifted from the surface, which necessarily slows down the process of writing. For example, the letter 'O' would normally be drawn in a single, continuous line; in calligraphy, this letter must always be formed by two downward strokes. Calligraphy demands a sensitivity of touch, easily appreciated by practising even the simplest lettering exercises. Variations between strokes are formed entirely by angle and direction, not by pressure on the pen.

The letter O is the basic form of the alphabet. Its shape sets the pattern for all other curved strokes. These illustrations (above, left to right) show characteristic shapes: the circular form of the Roman alphabet (pen angle 30°); the horizontal form of the uncial (straight pen); the oval, italic form (pen angle 30°); the flat-sided Gothic form (pen angle 30°); a pointed form (pen angle 30°); the ogee form (pen angle 45°); and a compressed vertical form (pen angle 60°). Combining different pen angles can be striking (top); this example shows a blending of Roman capitals and italic script.

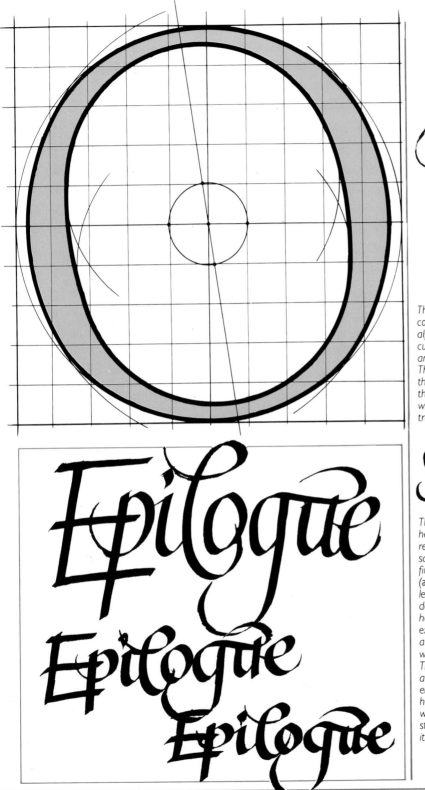

The diagram (left) illustrates the construction of the letter O in the Roman alphabet. There is a slight tilt in the main curves, the overall form being aligned on an angle of 82° from the centre point. The width of the letter is slightly less than that of a perfect circle. The thin curves of the letter are slightly less than half the width of the thick curves and the transition between the two is very gradual.

The number of nib widths to the body height of the letter is an important relationship in calligraphy. Letters of the same height can be light if drawn with a fine nib or heavy if drawn with a thick nib (above). Differences in the weight of the letters can be achieved by increasing or decreasing the number of nib widths to height instead of changing nibs; in this example (left), letters five nib widths high are fairly open; those that are three nib widths high are more dense, and so on. The balance of thick and thin strokes overall is also an important consideration. This embroidered T (top) shows the use of hairline flourishes. The difference in the weight of the flourishes and the main strokes ensures that the letterform retains its clarity.

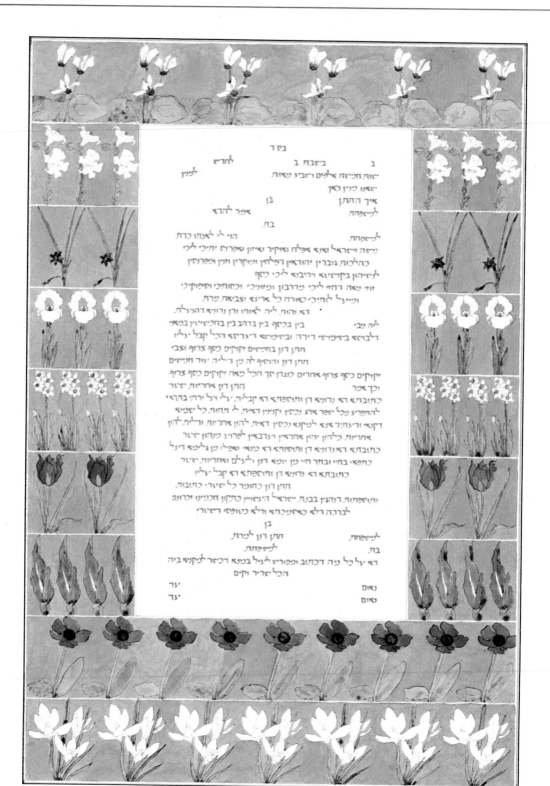

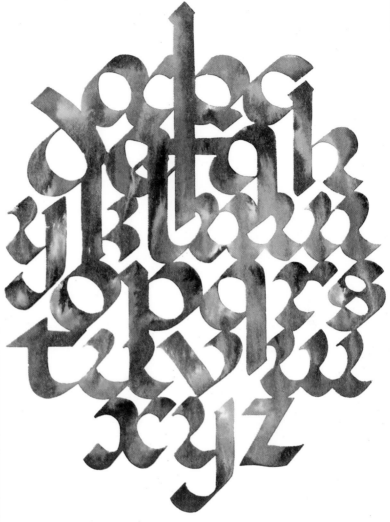

Calligraphy lends itself to display and ornament. This attractive piece, 'The Flowers of Israel' (left) is by Merilyn Moss. The fluent Hebrew lettering is as much a part of the design as are the ornamental border illustrations.

This multicoloured alphabet (above right) was silkscreened by Peter Thompson. The design is constructed of lower-case letters in a Lombardic style. The capital U (above) is by Imre Reiner. It exploits the basic letterform as a frame for an inventive and almost sinister modern illumination. It is in ink and watercolour.

Ornament and variety

It is possible to take great liberties in decorating letterforms, provided that the essential structure and internal space of the letter are maintained. The distinctive character of a letter depends upon whether it is described with straight or curving strokes, which of the straight strokes are vertical, horizontal or oblique and whether curved parts are open or closed. A curve which encloses space within a letter is called a bowl; the enclosed space is known as the counter. These internal spaces make a definite contribution to the character of individual forms, making them more than linear silhouettes. The proportion of letters is important, too; individual letters should be visually pleasing and all letters of a particular alphabet should conform to a logical proportional system. Provided that these ground rules are firmly borne in mind, the calligrapher who has developed a feel for the essential forms can feel free to experiment.

The Roman alphabet is based on geometrical models (below right), but subtle refinements and adjustments to individual letterforms prevent the letters from looking rigid or inelegant. The letter M is slightly wider than it is high. The second and third strokes curve slightly before they meet, making the form more open and less angular. The lower serif on the Z is curved outward slightly to draw the eye on. The O is based on a perfect circle and its curves are tilted at a slight angle. The E is half a square but the centre bar is slightly shorter than the other two and the bottom serif turns at an angle to lead the eye to the next letter. The direction and order of strokes is very important (below).

When copying an alphabet, look for its basic characteristics. Study the proportion of letters in height and width, between the body of a letter and the rising and falling strokes, and the general shapes of curving letters, whether they are round or elliptical, tilted or vertically stressed. Identify the weight of the lettering, the pen angle, the relationship of thick and thin strokes and the sequence of construction within each letter. These are the elements that govern the family likenesses between letters in an alphabet. They are expressed in the nature of curved strokes, the internal spaces in the letters, the serifs and the finishing strokes and the joining of strokes. Calligraphy is much more vital where these innate characteristics have been understood than where the calligrapher merely attempts to copy letters by eye.

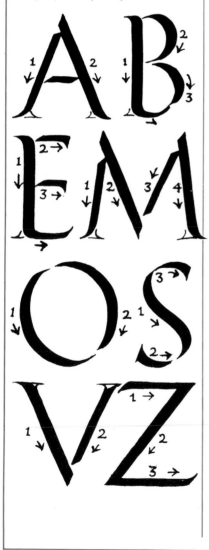

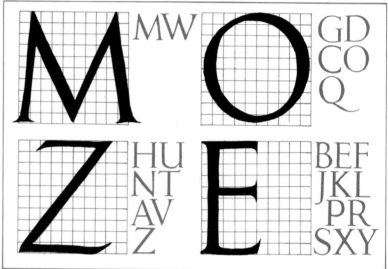

The Roman alphabet

The classical Roman capitals are not easy to construct as natural pen letters, because the forms were originally adapted to the action of the chisel. Although the finest surviving examples of Roman capitals occur in monumental inscriptions in stone, they were also written with the pen, which gives the strokes their thick and thin contrast. Roman square capitals are of enormous interest to the calligrapher as the origin of other written forms, and also because they are regular and finely proportioned. There have been many modifications of the original Roman lettering, which exaggerate or modify the thick-thin contrast and the construction of serifs to simplify the calligrapher's task. The skeleton Roman alphabet is based on strict geometric models, which are optically adjusted in pen lettering to maintain a balance within the letterforms themselves and in their relationships to one another

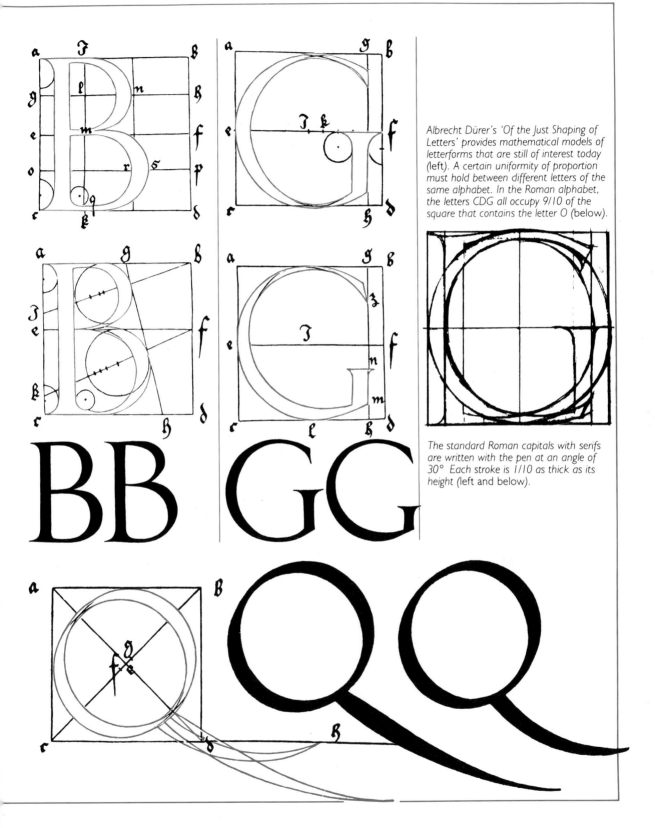

Albrecht Dürer's 'Of the Just Shaping of Letters' provides mathematical models of letterforms that are still of interest today (left). A certain uniformity of proportion must hold between different letters of the same alphabet. In the Roman alphabet, the letters CDG all occupy 9/10 of the square that contains the letter O (below).

The standard Roman capitals with serifs are written with the pen at an angle of 30° Each stroke is 1/10 as thick as its height (left and below).

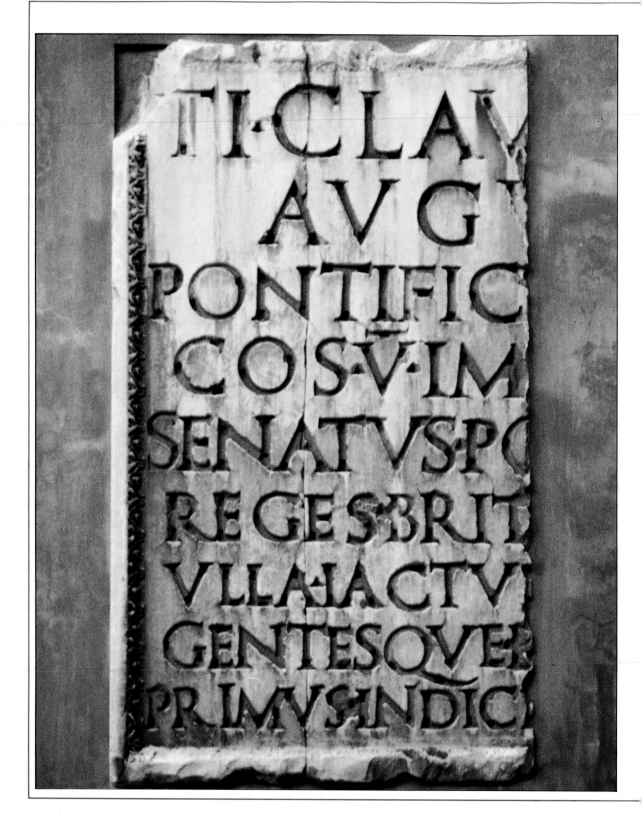

In simple terms, the majority of Roman letters are based either on a square or a rectangle, which is half of the square. The skeleton form of O is a perfect circle that fits exactly to the basic square. Q is also a circle, distinguished by its tail, which flows naturally from the base of the letter but does not cut the curve. M and W are based on the square, although the outer oblique strokes extend slightly beyond the boundaries. The curves of C G and D follow the circular O, but are cut to nine-tenths of the square. The narrow letters B E F I J K L P R S X Y all fit into the half-square. The remaining letters, H U N T A V Z are regularly

This example of ancient sculpted Roman capitals (left) is from the Arch of Claudius on the Palatine Hill in Rome. The same alphabet has been used for this modern example (below). It is a quotation from Goethe, written by Werner Schneider. The spare elegance of this form is particularly suited to inscriptions of this type, and works well reversed out of a dark background, as here.

WIR KÖNNEN
UNSEREN GESCHMACK
NICHT AM MITTELGUT
BILDEN / JOH WOLFG VON GOETHE
SONDERN NUR AM
ALLERVORZÜGLICHSTEN

This detail (above) from the Goethe quotation shown above, demonstrates how the Roman letterforms can be adapted to the demands of another language; in this case, the umlaut, represented here and in the U in the last line of the quotation by an enclosed superior E.

proportioned within eight-tenths of the square. X and Y, like M and W, extend outside the rectangle in the oblique strokes. Thus, there are four basic frames for the proportions of all Roman capitals. Each one is clearly distinguishable by the strong contrasts between straight and curved elements.

Certain modifications have been made to the position of cross-strokes and the curve of bowed letters to establish proportions that are optically satisfying. In a basic skeleton form, for example, B can be, in effect, formed of two D shapes, one on top of the other. The two bowed sections would then be equal, coming together at the centre line between top and bottom. In practice, the lower bow of B is slightly enlarged and the two curving strokes meet above the centre line, otherwise

ABCDE
FGHIKL
MNOPQQ
RSTUⱽᵥ
XYZᶻz

The imposing formality of the Roman alphabet reflects the rigid, military structure of the society in which it was created. The elegant, square capitals — or quadrata — are frequently to be found in monumental inscriptions, carved in stone. These capitals (above) date from the second century AD.

the letter appears top-heavy. The modification is subtle and it is a common mistake to exaggerate this difference, an over-compensation that should be avoided as it makes the letter inconsistent with the structure and proportion of other forms. Likewise, the lower bowl of S should not be allowed to overtake the scale of the upper section.

The cross-strokes throughout the centre of E G and H are placed slightly above the centre line, so that the bottom edge of the pen stroke sits on the line. By contrast with the usual habit of fixing the optical centre of a letter just above the actual centre, the bowls of R and P drop below the centre line so the enclosed counter has a clean, open curve corresponding to the circular form of O. The cross-stroke of A is also lowered so that the enclosed triangular space is not cramped and disproportionate. The branching of Y crosses slightly below the centre line whereas the oblique strokes of the X cross slightly above the centre, leaving the lower triangle fractionally larger than the upper.

The proportions and optical corrections are described to explain the relative constructions. When practising Roman capitals with the pen it is not necessary to draw a complex grid and slavishly repeat the geometric proportions. It is better to study the models and try to achieve the strokes naturally, using the pen angle and weight of the lettering as guidelines.

The angle of the pen nib for Roman capitals is 30° from the horizontal writing line. This means that the thick-thin contrast in most of the letters is not extreme, since the oblique strokes do not directly correspond to the edge of the nib or its full width. The height of the lettering is seven nib widths, but the thickness of the vertical stroke, because of the pen angle, is one-tenth of the height. Because of the width and angle of the pen, the narrowest sections on the curve of O become tilted. As previously described, the O is formed by two semi-circular pen strokes; first the left-hand curve, then the right, meeting at the narrowest point to the right at the base of the letter. Vertical and oblique strokes are drawn from top to bottom. The cross-strokes of A E F H and T are the final strokes of these letters.

The serifs of Roman capitals correspond to the chiselled forms of incised lettering. However, they are more difficult to achieve with the pen because they are delicate and fit on a geometric curve into the stem, which is not automatically formed by continuing the stroke. The serifs finish with an edge at right-angles to the structural stroke; the curve attaching it to the stem is a perfect quarter-circle. To achieve this with the edged pen it is necessary to turn the nib angle and work at right-angles to the main stroke. The curves are made by drawing short strokes with the edge of the pen coming in from left and right and following into or out of the stem. The flat edge of the serif is then made regular with a fine hairstroke.

Later variations
These details (above) are from inscriptions carved by Filocalus, a craftsman of the fourth century AD. The curling serifs contrast with the usual austerity of Roman capitals and prefigure a favoured motif of Victorian lettering. Rustic capitals (below) are a less formal version of the Roman alphabet, developed to enable scribes to write more quickly. This compressed, vertically elongated form became popular as a book hand, and was used commonly for main headings or secondary titles.

ABCΔEF NOpqRS

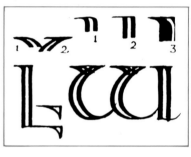

Uncials

Uncials followed the Roman square and Rustic capitals and were the result of the need to write in a formal style, but more quickly than is possible using the stately, deliberate capital forms. Uncials are bold, upright and rounded. They are natural pen letters, having simple constructions and finishing strokes, fluidly contained within the fixed angle of the pen and the direction of strokes. The existence of two or three alternative constructions for more than half of the letters indicates that the uncial was an adaptable and highly practical hand. These variations all fit within the general family characteristics of uncials, but are an indication of how speed in writing tends to produce natural modifications of form.

Uncials were the standard book hand of scribes from the fifth to eighth centuries, later superseded by the half-uncials and the rapid development of minuscule scripts. Uncials and half-uncials were taken to monastic settlements in the north and west of the Roman Empire by Christian missionaries. In Ireland and the north of England they developed into what have become known as the Insular scripts. The tradition evolved of writing the gospels in the form of highly decorated codex books; two of the finest are the Lindisfarne Gospels and the Irish Book of Kells.

These English and Irish half-uncials technically remained majuscule scripts; they were preserved concurrently with the development of minuscule, cursive forms of writing. At the same time, such scripts were being developed in other centres of scholarship throughout Europe; at Luxeuil in France, Bobbia in Italy, the Iberian peninsula of Spain and in the area ruled by the Merovingian kings of the Franks in northern Europe. Clearly, although local variations were numerous in the period of confusion following the collapse of the Roman Empire, the

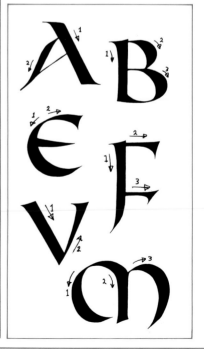

çhıjkLm

TuvwXyz

The uncial alphabet (above) is made with
the pen held horizontally. This gives the
marked contrast between thick and thin
strokes; the verticals are the broadest
strokes and the letters have a squat
appearance. There are two ways of
making serifs in the uncial script (left).
For serifs extending to left and right, a
light stroke made from the left is crossed
by a similar stroke from the right, which
continues into the main curve. Otherwise,
the pen can simply be pulled to the right
to create a serif.

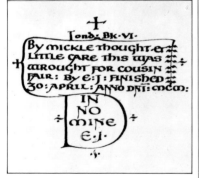

This is a sample of Edward Johnston's
early form of signature (above) using a
variant of uncial script. The signature
itself reads: In nomine dei; the ei of Dei
are written as e.j., Johnston's initials. This
form was abandoned later, as he
considered the work immature and
believed that the letters lacked the
sharpness necessary for good lettering.
This example (left) shows the sequence
and direction in which the uncial strokes
are made.

missionaries travelling between the many monastic centres
provided a link in developing written forms.

Uncials were somewhat neglected during the revival of formal
calligraphy; they were not promoted as enthusiastically as other
forms of lettering such as italic and Foundational hand based on
tenth-century script. More recently, uncials have found favour as
a highly decorative and vigorous alternative to straightforward
capital and lower-case forms. Despite their association with
some of the finest early Christian manuscripts, they seem to
have a curiously modern flavour, which is well-suited to
contemporary ideas of design.

Uncials are a straight-pen written form, where the pen is held
with the edge of the nib parallel to the writing line. The thinnest
strokes are precisely horizontal and the thickest vertical. Uncials
are naturally quite heavily textured, although they are also
pleasantly open as a result of their rounded constructions. The
uncial O is a round character, but because there is a pronounced
thickening of the curves on either side, the pen form extends
across the circular skeleton. The inner space follows the curve of
a circle more closely than does the outline of the form.

Serifs occur as natural extensions of the pen strokes; on a
vertical stem, for example, the serif is formed by pulling the pen
from a leftward direction to form a fine line flowing easily into
the broad stem. It can be squared off at the right-hand edge by
drawing the pen down vertically over the original curve. The
rounded version of W has a serif extended both ways; this is
made by a light stroke coming in from the left, crossed by a
similar stroke from the right, which follows into the main curve.
Since the edge of the pen is horizontal in forming these strokes,
the evenness across the top of the serif is automatically
established. In general, the curved and extended strokes of

uncials have a naturally graceful finish owing to the rhythm of the pen's progress; tiny hairline 'tails' can be created by a quick twist of the nib before lifting the pen.

The uncial alphabet form clearly shows how a mixture of lettering principles can be represented and form a cohesive style. An alphabet may consist of capital letters, which are all based firmly on the writing line and rise to an even height above it, or of lower-case lettering in which there is a basic body height for the letters and rising strokes, called ascenders, complemented by tails of letters dropping below the line, called descenders. In typography, alphabets are generally paired in corresponding sets of capital and lower-case forms. In calligraphy this is not always true, particularly in the formal scripts up to medieval times, which show more complex developments in the structure of written forms that were only later standardized.

The uncial was followed by the half-uncial (below). Here one can see the letters breaking through the writing line with noticeable ascenders and descenders. Half-uncial script was secondary to uncial and both were later replaced by formal minuscule alphabets like the Carolingian. The half-uncial still clearly shows the influence of the Roman square-edged pen, in its characteristic thick and thin strokes.

abcdefghijklmn opqrstuvwxyz

Showing characteristics of both uncials and the modified tenth-century hand, this example (far right) was written holding the pen at a slight angle. The overall effect, however, is that of an uncial script. The variation in tone of the pen strokes on the textured paper and the ragged line lengths, are evenly balanced in the composition.

Carolingian minuscules

The Carolingian minuscule was developed by Alcuin of York (735-804) at Tours, as part of the literary renaissance generated by Charlemagne. Charlemagne's power as king of the Franks and subsequently Holy Roman Emperor ensured the wide dissemination of this new book hand. Based on forms from the fourth century, it is a graceful and legible style in which the letters are joined and rounded. They resemble the uncial forms on which they are based, but are smaller and have thicker ascenders. The Carolingian book hand was modified during the tenth century to a heavier, more compressed style, a precursor of the Gothic.

Modified tenth-century hand

The modification of tenth-century minuscule script produces a rounded, vigorous letterform, naturally adapted to the movements of hand and pen. There is both invention and adaptation in this alphabet, as in the curving forms of V and W, and in the regular vertical emphasis of a and g in the minuscule form, which are more freely written in the earlier versions. In addition, the tenth-century manuscripts often show use of the long s, which to modern eyes appears to be f; in the modified

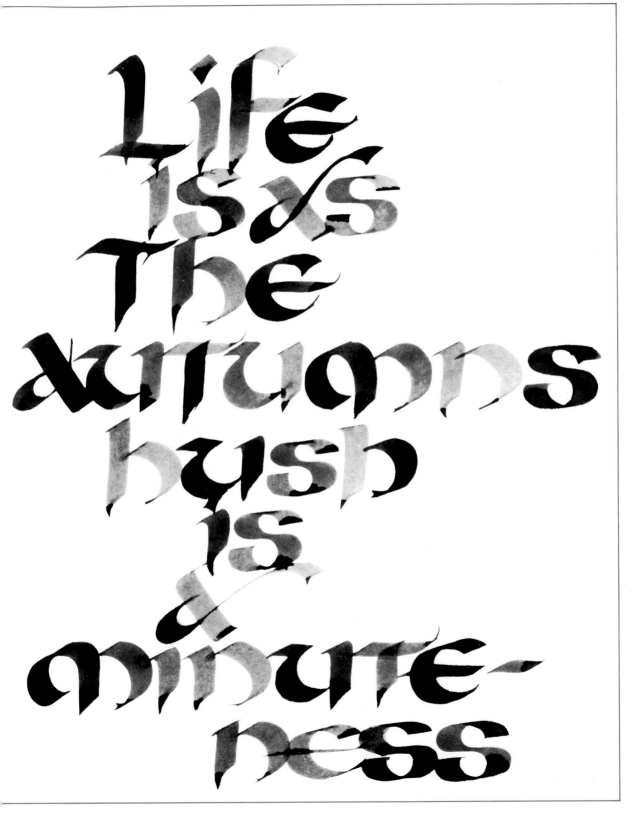

Life
is as
The
autumns
hush
is
a
minute-
ness

abcd
efgh
ijklm
nopq
rstu
vwx
yz

abcd
efgh
ijklm
nopq
rstu
vwx
yz

A comparison of tenth-century Carolingian minuscules (right) and modified tenth-century hand (far right) shows clearly how the latter thickens and elaborates the strokes of the former. Both hands seem slightly heavy and awkward to the modern eye, accustomed to more cursive scripts. The formation of the serif in modified tenth-century hand (below) is a simple, three-stage process.

The capitals of the modified tenth-century hand (below), like the lower-case letters, are written with the pen at an angle of 30°; the weight is four nib widths to height. This is a rounded, almost cursive hand, designed for clarity and ease; the letterforms should be written fairly close together to emphasize the rhythm and coherence of the strokes.

ABCDEFGHIJKLMN
OPQRSTUVWXYZ

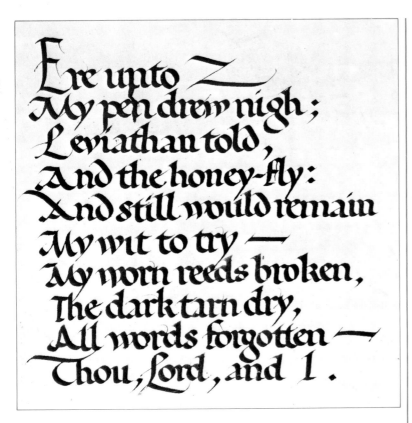

A typical example of minuscule writing is this latin text (above). This modern interpretation of modified tenth-century hand and Carolingian minuscules (above left) is most effective. The choice of text is apt to the script, and the spacing is very well judged: close enough to preserve coherence, without appearing cramped.

hand, the s conforms to the expected shape in relation to the other letterforms. The alphabet of capitals has been systematically constructed to accompany the modified script and is not typical of tenth-century capitals, when versals and adapted uncials were common, with much variation and ornament.

Like the Roman capitals, this hand has a regular system of proportion and a subtle graduation of thick and thin strokes, but it is open, broad and less severe than the square capitals. The pen angle used is 30°, as with the Roman capitals, which gives the tilted, circular O. The lettering is quite sturdy and compact. The vertical and rounded forms are dominant, so in letters that have a vertical stem this is usually the first stroke written.

Serifs at the top of vertical strokes are simply formed by a slight curve starting from the stroke from the left, and then overlaid with a vertical stroke to sharpen the right-hand edge. Less formally, in oblique strokes the fluid motion of the pen is allowed to begin and end the stroke in a logical manner — tails curve naturally with a tiny flourish as in the minuscule g k and y and the capitals K R and X. This script almost has the freedom of a cursive hand and the letters should be closely spaced so there is a lively horizontal linking between the forms, occurring easily through the characteristic rhythm and direction of the strokes.

Gothic scripts

During the eleventh and twelfth centuries in Germany, France and England the style of minuscule writing became increasingly compressed and fractured; it formed an extremely dense, matted texture on the page. This particular form of Gothic lettering became known as Black Letter. Northern styles of Gothic Black Letter are known as Textura, in reference to the woven appearance of the page of text. Many different formal and informal styles of Gothic script emerged during the thirteenth and fourteenth centuries; two of the main formal variations were *textus prescissus*, with the vertical stems of the letters standing flat upon the writing line, and *textus quadratus*, which has the characteristic lozenge-shaped feet crossing the base of the stems. A number of cursive Gothic hands were also developed, characteristically angular and pointed with exaggerated ascenders. This general style was termed *littera bastarda*, to indicate that it was not a true script but a mongrelized version of the formal script.

The compression of Black Letter writing, its angularity and rigidly vertical structure, was a development based on speed and economy in writing, which was also stylistically in keeping with other art forms of the period. Its rich, dense texture is picturesque and ornamental and it evokes many associations with the highly decorative Gothic illuminated manuscripts.

The standard Gothic Black Letter serif (above, 1 to 3) is formed by a single pen stroke with the nib angled at 45°. The Fraktur (above, 4) is formed by a light downward stroke preceding the main stroke. Two alphabets (below) show variants of the Gothic form: fifteenth-century Gothic majuscule, after Dürer (top); Rotunda majuscule from the fifteenth to sixteenth centuries (bottom).

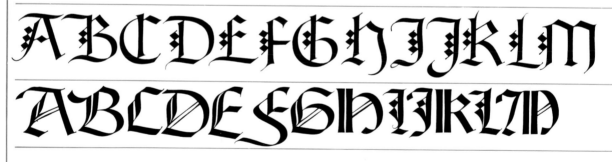

Rudolf Koch (1874-1934) was responsible for carrying on the traditions of Gothic Black Letter in Germany in the twentieth century. This piece by Koch (right), written in 1933, demonstrates some slight modifications to the standard script, particularly in the use of hairline strokes as decorative space-fillers.

Ist Gott für uns, wer mag wider uns sein? Welcher auch seines eigenen Sohnes nicht hat verschonet, sondern hat ihn für uns alle dahin gegeben, wie sollte er uns mit ihm nicht alles schenken? Wer will die Auserwählten Gottes beschuldigen? Gott ist hier, der da gerecht macht, wer will verdammen? Christus ist hier, der gestorben ist, ja viel mehr, der auch auferwecket ist, welcher ist zur Rechten Gottes und vertritt uns .

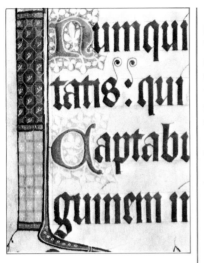

This detail from the fourteenth-century Luttrell Psalter (above) shows Gothic script combined with decorated capitals and border designs. Two minuscule alphabets from the fifteenth to sixteenth centuries (bottom) show variations between the standard Gothic (left) and the smoother, more cursive Rotunda (right).

At its most formal, Gothic Black Letter could be written as a series of evenly spaced verticals, which might then be adapted to form any letter by the addition of oblique joining strokes, abbreviated cross-strokes and extensions ascending or descending from the body of the text. When it is presented in this type of systematic patterning, it is almost illegible to modern readers. However, it would seem that the vertical stress of Gothic lettering was widely accepted by its contemporary readers, since it formed the model for the early type designs of the Gutenberg Press.

The pen angle for the Gothic forms is 30° to the writing line. The weight of the writing may vary; Black Letter is usually quite heavy, for example in a range of about three to five nib widths to height, and it is more difficult to control the evenness of patterning if the strokes are finely made. Serifs and joining strokes are formed in much the same way; the constructions should be carefully studied to see how these elements are differentiated. The lozenge-shaped serifs are not precisely centred on their vertical stems, but set slightly to one side. The Fraktur serifs consist of two spars branching from the stem, with more emphasis on the right-hand branch. The curious construction of X in this alphabet eliminates the usual crossing of two oblique strokes and subordinates the form to the consistency of vertical emphasis.

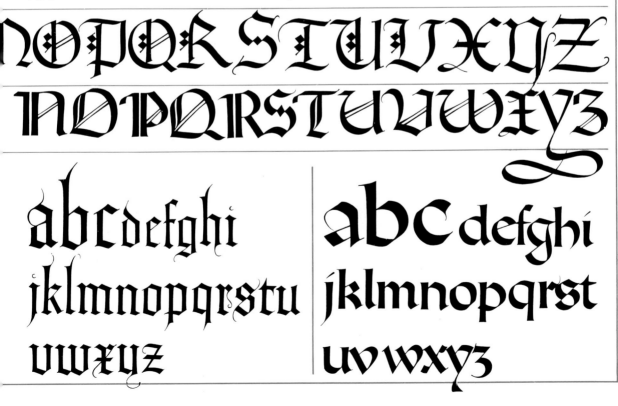

Italic

Italic was the typical pen form of Renaissance Italy. It came into being in the interest of developing a greater writing speed while maintaining an elegant, finely proportioned form in pen script. The characteristics of italic are the elliptical O, on which model all the curved letters are constructed, the lateral compression and slight rightward slope of the writing, and the branching of arched strokes flowing rapidly out of the letter stems. Compressed, angular hands are naturally quicker than rounded forms and italic is the most easily adapted to informal, cursive handwriting. This was the main reason for its original development, but it was also refined and formalized; examples of work by early writing masters often show tremendous virtuosity, making elaborate use of ascenders and descenders.

Italic is by nature a lightweight form and is usually written with a nib width narrower than those used for the rounded forms of

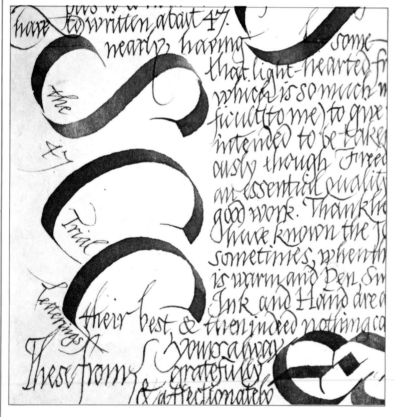

This detail (above) is from the left-hand corner of a letter written by Edward Johnston, the single most influential modern calligrapher. The texture of the handwriting is offset by the large initials of the sender (EJ) and the recipient, Sir Stanley Cockerell (SCC).

A comparison of cursives (right): the Merovingian documentary cursive of the eighth century (bottom) developed to the firmer Carolingian documentary cursive (top) in the tenth century, and thence to the elegant English diplomatic Gothic cursive of the thirteenth century (centre).

medieval book hands. There is less variation in the widths of italic letters, but they are elongated, with extended ascenders and descenders. For this reason, the height should be carefully controlled to keep the pen strokes firm and cleanly curved. In keeping with the flowing elegance of italic, the tails, ascenders and descenders are often elaborately flourished or looped. For practical purposes, a simple, basic form is easier for the beginner and as the movement of the script becomes familiar, further elaboration can be made.

Italic is most commonly written in the lower-case form, with capitals as appropriate; the capital alphabet is like a compressed version of Roman square capitals. The weight is most easily fixed at four nib widths to the height, a further three each for the ascenders and descenders. The capitals are seven nib widths high, based firmly on the writing line, to align with the body height and ascenders of the lower-case forms.

This medieval legal document (below) is a typical example of the elaborately flourished and decorated forms popular at the time. The flourishes within the text are restrained in the interests of legibility, but the initial E and the capital H of the name, John Hamond, show two levels of ornament, appropriate to their positions in the text and to their importance.

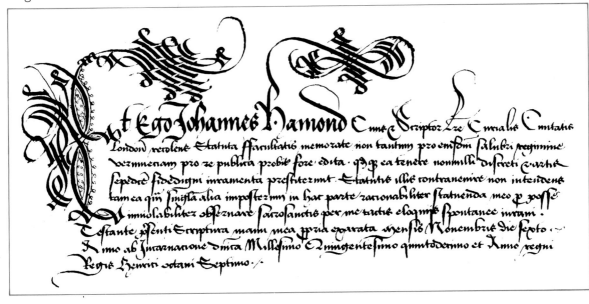

The pen angle is 45°. The lettering may be upright or sloped, but never more than 5° from the vertical. A pronounced slant is unnatural and an unnecessary exaggeration. The direction and order of the pen strokes follow the usual guidelines. In arched letters such as h m and n the pen can be turned at a sharper angle in the branching from the stem and the finishing curve, to narrow the fine strokes. It takes time to learn control of varying the pen angle and for initial practice, the fixed angle of 45° produces a logical and well-proportioned letter.

The basic serif of the italic alphabet is a hook, formed by pushing the pen upwards briefly from left to right before following down into the stem. Loops and tails are finished on the

natural curve of the pen stroke. It is common to see ascending strokes carried over on a curve to the right, following the general emphasis of the lettering. Serifs on the capital forms are also natural pen hooks, following the main curve or using a pushed or slightly twisted stroke. There are many examples of elaborately flourished italic capitals; this is one of the most varied forms in terms of decorative modifications. Models for alternative forms can be found from studying Renaissance and modern manuscripts and copy-books. Italic is a fluid, cursive script, regular and easy to read without being overly formal. Although ascenders and descenders are often elaborate in this hand, it can be just as effective to restrict the use of extra flourishes to initial capitals. Flourishes should always be used for a specific purpose: as decoration in the margin; to balance the design, where space permits; to emphasize the flow of the line.

Versals

Versal letters are large or small capitals that are used to denote the opening of a chapter, paragraph or verse (hence the name versals), and to mark important passages in the text. In early manuscripts, versals were simple forms based on Roman capitals. In Italy, there later developed a more exaggerated, bulging form often referred to as Lombardic, after the region where this style was first introduced into hand-lettered manuscsripts. Lombardic versals had their roots in the rounded forms of uncial letters. Versal letters were the basis of the compound forms in highly decorated medieval manuscripts, which were also ornamented with gold and bright colours.

Versals differ from the alphabet styles so far discussed, because they are built-up letters. While still dependent upon the pen stroke for their basic character, it is not a single stroke that

These samples demonstrate the variety of forms to which the italic hand can be adapted. The earliest (top) was published in Italy between 1560 and 1570. More modern examples (above, top to bottom): traditional modern presentation piece, English; an American example, combining Roman capitals and italic script in a balanced and considered way; a detail from a Finnish piece, showing how elaborate serifs draw attention to a piece of writing; and a German interpretation of the italic script, in which the elegant forms retain the characteristic elliptical O and acute arching strokes in the M and N of the italic hand.

A fine, flowing hand, the italic alphabet (below) is most often used in the lower-case form. The pen angle is 45°; the writing may be sloped slightly to the right. The weight is usually four nib widths to the body height, three each for ascenders and descenders, italic being a lighter script than other hands. Capitals are seven nib widths high and resemble a compressed, fluent form of Roman capitals.

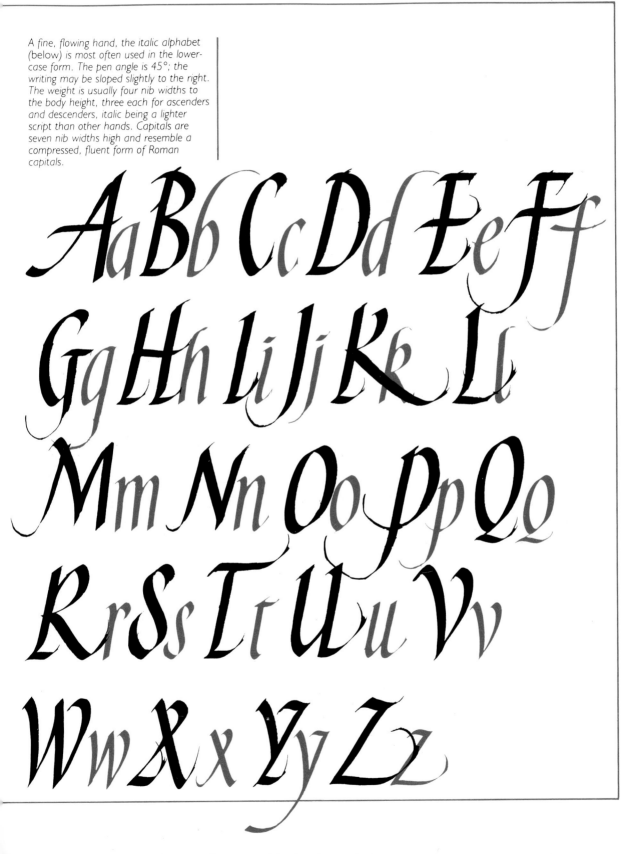

The changing face of italic.
*Two early examples and one from two
centuries later show how the italic form
was elaborated over the years. The
lettering of this Book of Hours, executed
in 1540 (below) and of an early printed
book from Italy (right) bearing the date
1523, are notably restrained and
compressed when compared to a sample
alphabet written in 1777 (bottom).*

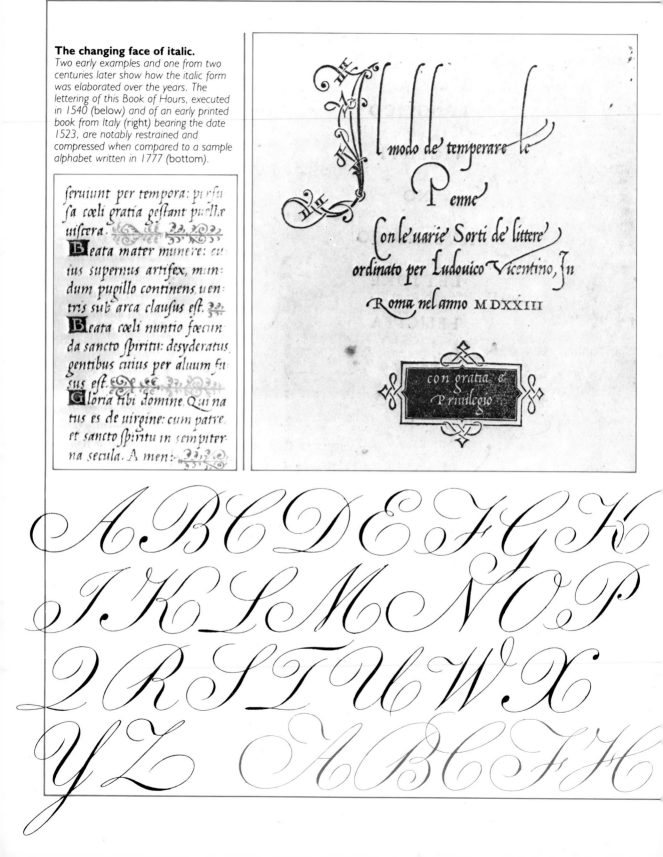

forms the shape and thick-thin contrast. The stems of versal letters are formed from two outer strokes which are quickly filled, or flooded, with a central stroke. They are drawn, rather than written. It is usual to make the outer, left-hand stroke first, then the inner and flood in the central stroke immediately. However, when forming curved letters the inside is the first stroke to be formed.

There are a few practical points of technique to note in relation to versal letters. The board used as a support for the work should be lowered to a shallow angle. The width of nib used should be slightly narrower than that applied to the main body of the text. A quill is often used, with a slit lengthened to ½-¾in (1.2-1.9cm) long, which allows the paint, watercolour or gouache that has been diluted to a rich, milky consistency, to flow smoothly through the nib.

The quill is held perpendicular to the writing line as the main outline strokes are drawn and filled, but horizontally when applying cross-strokes, serifs and hairlines. The cross-strokes start at the width of the nib and are splayed in two flaring

This versal alphabet (below) is in the Lombardic style, a curved, more exaggerated form based on uncials. Cross-strokes and serifs in both types of versals are wedge-shaped; the Lombardic versals, in particular, are often finished or flourished with fine hairline strokes.

strokes at the end to produce the wedge shape. Hairline strokes form a clean right-angle to the main stroke and are not moulded into curves as in the classic Roman capitals. The curves of bowed versals are exaggerated slightly; the inner curve may be flattened and the outer curve made more pronounced. Once the outlines of a stem are drawn the centre should be flooded with the third stroke immediately, laying down enough paint to give the letter a delicately raised effect when dry.

Versal letters in a body of text may be written in the margin, set into the text or positioned symmetrically on a line between the two. Traditionally, built-up letters are added after the general text is completed. If the versals are set within the text the necessary space must be calculated beforehand and the opening lines of text adjusted to accommodate them. Where versals fall in a vertical line down the margin, especially if they occur on every line or almost as frequently, they provide a more rational arrangement if they are centred on a vertical axis rather than aligned at one side. Otherwise the different widths of the letters can create a jumbled or apparently random design.

Elaborate versals were a feature of many early manuscripts (below). This thirteenth-century English manuscript (right) uses Gothic script with heavy ornaments filling in the ragged lines.

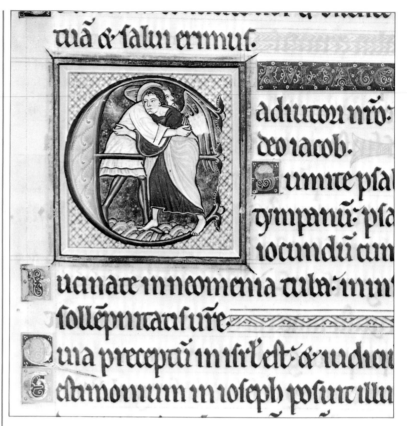

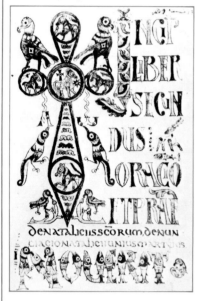

Versals lend themselves to elaboration. These modern capitals (below) experiment with spacing and decorative elements, producing a stimulating combination of visual images.

These florid Victorian versals (left and below) show how the elaborate written forms lend themselves to printing. These ornate variations were immensely popular in both written and printed works of the period; the permanence of copperplate engraving justified the time needed to achieve such spectacular flourishes.

Recent practice and innovation

Although the basic forms and structures of letters have remained virtually unchanged for centuries, there is still plenty of scope for invention and originality in calligraphy. Students of the original calligraphy masters have themselves become notable scribes and lettering designers and, in turn, have taught their own pupils particular traditions and new lines of enquiry. Various formal bodies exist to promote the lively development of new calligraphic forms. In England, the Society of Scribes and Illuminators was set up in 1921. Similar societies exist in many countries and in recent years have broadened their membership to include the growing number of interested amateurs who both study and practise the principles of fine writing. International exhibitions are organized, which attract entries from all over the world. Although there are language barriers to overcome and different alphabets and characters are used in different parts of the world, there is much exchange of ideas and promotion of common interests.

The United States has had its own strong tradition of calligraphy and lettering art in the twentieth century, less bound to the influence of medieval penmanship than that of Europe but still informed by the principles adhered to by modern scribes, several of whom have visited and taught in the United States, and a few of whom have settled there.

European calligraphers have also contributed greatly to the development of new letterforms. The German tradition is

This alphabet (below) was designed by Gunnlaugur SE Briem. It refers to the thick and thin contrasts of forms written with a broad-edged pen, but this is suggested only by the subtly broken outlines. Because the letterforms have no solid weight, the shapes are modified but each letter retains the essential characteristics of its construction, so it is clearly recognizable.

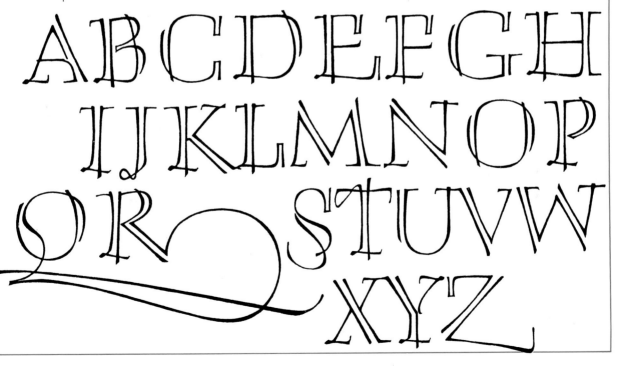

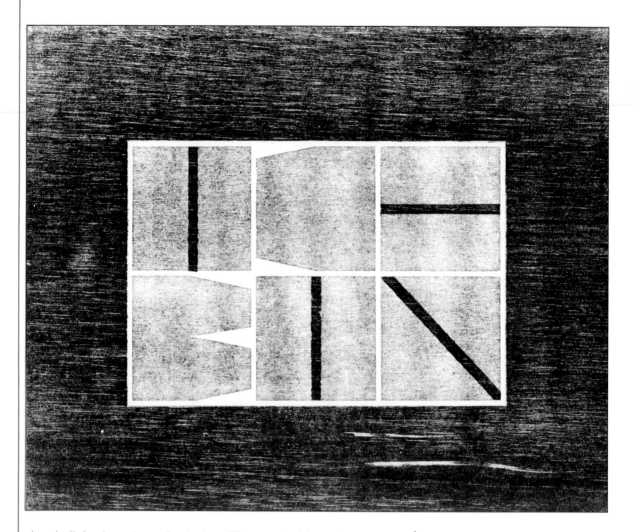

closely linked to that of printing. The survival into the modern period of Gothic Black Letter, as a standard typeface used in Germany, has given the northern tradition of calligraphy an unbroken link with its past. The influential German calligrapher Herman Zapf is well known for the design of typefaces; amongst his creations are the eponymous Zapf, popular in America, and common book faces like Melior, Palatino and Optima.

Unfortunately, for a number of reasons, calligraphy has been virtually abandoned as a formal discipline of art school teaching; schools tend to place greater emphasis on printed forms and mechanical lettering in modern design courses. The art of calligraphy still flourishes, however, in local societies, workshops, day and evening classes and weekend schools.

There are a number of avenues for inventive calligraphers to explore, among them the development of new alphabets, unconventional layouts and new media. There is absolutely no

Wood block letters by Hans Schmidt (above) demonstrate an interesting interpretation of essential letterforms. Each letter is fitted to a square module, curves are represented by shaving the outlines and the black bars provide a further clue to identity. The abstract pattern spells out the words ICH BIN

It is an interesting exercise for western calligraphers to experiment with unfamiliar alphabets. This detail of a piece of writing in cyrillic (above) is by the Yugoslavian Jovica Veljovic.

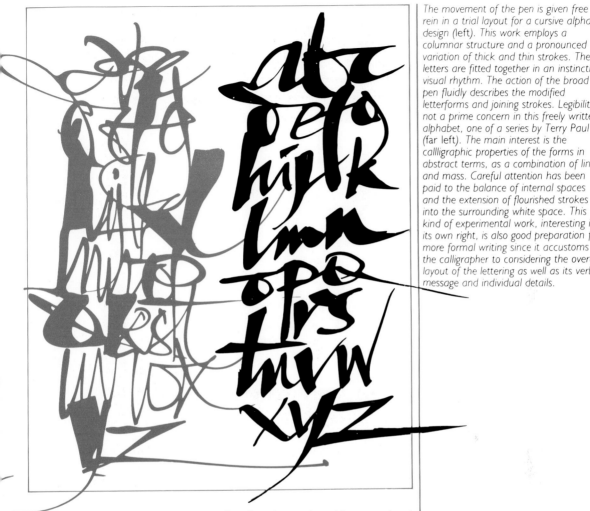

The movement of the pen is given free rein in a trial layout for a cursive alphabet design (left). This work employs a columnar structure and a pronounced variation of thick and thin strokes. The letters are fitted together in an instinctive visual rhythm. The action of the broad pen fluidly describes the modified letterforms and joining strokes. Legibility is not a prime concern in this freely written alphabet, one of a series by Terry Paul (far left). The main interest is the callligraphic properties of the forms in abstract terms, as a combination of line and mass. Careful attention has been paid to the balance of internal spaces and the extension of flourished strokes into the surrounding white space. This kind of experimental work, interesting in its own right, is also good preparation for more formal writing since it accustoms the calligrapher to considering the overall layout of the lettering as well as its verbal message and individual details.

need for the amateur to feel confined and restricted by standard copy-book forms and design 'rules'. Modern calligraphers are almost daily taking greater and greater liberties with the traditional tenets of the art, even to the extent of sacrificing legibility to design. Calligraphy is being used in traditional applications with modern variations, such as when an inscription is made in stone using an innovative alphabet, or a public notice is written in a formal script but is laid out in an unexpected way. Modern technology has also opened up new media, which carry their own characteristics into the design of letterforms for which they are used; acrylic paints, letters cast in metal or plastics, sandblasting glass or stone are all wellsprings of new ideas. One new medium that has recently been turned to calligraphic use is Petrarch, a resin-bonded, reconstituted slate developed by a brick company; it has a consistency similar to that of some plastics and fine flourishes can be achieved on it by sandblasting.

DISPLAY AND DECORATION

The essence of good calligraphy lies in fitting form to meaning. It is no easy task, however, to cope simultaneously with the verbal significance of lettering and its abstract visual qualities. Legibility is also a prime consideration for most calligraphic tasks. When designing a piece of work, it is wise to ask yourself in what way the design contributes to the content. The nature of the text will often suggest a style of presentation; each piece will present different problems and opportunities. Although basic guidelines for spacing and design can be given, no one system will apply to every situation, nor will the same device perform the same function in different contexts. The calligrapher will learn only through individual experiment; good design is a matter of informed decision-making but it can also result from having the courage to break the rules.

A simple standard measure for spacing between words written in lower-case letters is the width of the letter n (below); the equivalent for capitals is the letter O

wordnspacing
isnannessential
element.

Points to watch for when spacing text (below) include the space between and within letters, and spaces between lines.

THE FUNDAMENTAL SHAPES OF LETTERS

WORDS WORDS WORDS

1 WORDS

2 WORDS

3 WORDS

There are a number of ways to space a word, some more successful than others (left). Overlapping letters can be effective, but often look cramped (1). Calculating the available space and dividing it equally between the extreme edges of each letter tends, surprisingly perhaps, to look uneven and gappy (2). Good visual spacing (3) allows proportional space between letters, so that the word looks even. Judging by eye is generally the most reliable method, but no one system is ideal for every case.

There is no such thing as correct spacing of letters, because this is relative to the weight of the letters and the overall density of the text. There are a few rules of thumb that provide basic reference points for spacing, but in a complex arrangement the calligrapher must make continual optical adjustments. Spacing is judged by eye, not by a system of mathematical proportion. The best equipment a calligrapher can bring to a design is a full consciousness of the positive importance of space. The consistency of alphabet forms and the family relationships of shape and proportion ensure a rhythmical pattern in writing.

Consistency is not the same thing as uniformity, which can have a deadening effect. In calligraphy, the slight modifications of form that naturally occur are signs of life. There are distinct variations that could be applied to the appearance of a single letter, which correspond to logical design principles. The design of a written page takes into account the spaces between and within the letters, between words and lines and the width and evenness of margins. Further considerations might include the contrasts between different letterforms, or between letters and decorative forms, and also the balance of tone (black and white) and colour. All the components of the design are mutually affective and create visual sequences that may be modified or rearranged as required. This process is a combination of instinct, acquired knowledge and anticipation.

The texture of writing, whether heavy or light, is consistent to the degree that the same letterform is used throughout. Devices that cut into this even texture natually stimulate attention. The clearest illustration of this principle can be seen daily in the visual organization of newspaper pages. Hierarchical values, shown in size and weight of type, are applied to headlines, sub-headings, by-lines, quotes and solid text. To a literate person, reading seems a smooth and easy process, but it is actually performed in a series of jumps and pauses. The pauses occupy a high proportion of reading time and provide a period for the reader to recognize and absorb the words; the jumps propel the eye through the text. Humans read by recognizing the shape of words. Each person acquires a memory-bank of words that are understood at a glance. A wrong or missing letter may be remarked but it rarely interferes with the reading of the word. Recognition does depend on a familiar order of the pattern, however, which is why words written vertically or back to front are more difficult to identity. A text written in capitals is more tiring to read than one in lower-case. This is partly because of the increased number of verticals, but also because of size. There is a focal point of vision beyond which a certain number of letters remain peripherally clear. Lower-case lettering has a more complex texture than that of capitals and ascenders and descenders aid legibility by giving more clues to recognition.

Different letterforms carry their own associations for the reader, and the choice of form will affect the impact of a design. Gothic lettering is normally associated with the German language, so its use for German words (above) is predictable, if traditional. German words done in uncials (top) or French in Gothic (below) create a deliberate discord, which can be far more striking than a more familiar or expected style. The calligrapher must bear these associations in mind when selecting a letterform.

Designing calligraphy for a specific purpose, such as a book title, involves further considerations. The letterform must suit the subject and overall design of the book, and it may also need to accord with type used around it. Weight and ornamentation must be balanced to avoid a 'fussy' look, and the scale of the finished jacket must be taken into account.

Calligraphy

Calligraphy

Calligraphy

the complete calligrapher

The Complete Guide to
Calligraphy
Techniques and
Materials

The complete guide to
Calligraphy

Colour and decoration

The two basic ways of using colour in calligraphy — to write in colour by feeding liquid paint into the pen or to add drawn and painted decoration — are well represented historically by both simple and highly complex forms of ornamentation. Gold is not strictly regarded as a colour and is considered a separate element, additional to an overall scheme of colour. It is still used in specially prestigious work, for capital letters and particular ornamental forms and sometimes also for whole lines or even blocks of text.

Black and red is a simple, traditional colour scheme in calligraphy. It is not known precisely how the convention arose, but it makes sense in visual terms. Red is a clear, strong colour that forms a striking contrast to black, while being sufficiently dense to sustain its presence in the overall balance of tones. In the matter of colour and decoration, study of illuminated manuscripts quickly demonstrates the freedom felt by the scribes and their confidence in their own skills and the materials to hand. There are examples of ornamental writing and design that closely relate to the style of the edged pen, others which display a free hand in drawing and the extension of pen-lettered forms.

Some basic ideas of design contained in early works can be usefully extracted for a contemporary context. The habit of developing decoration in reference to plant forms, animals and human figures, for example, is not incongruous in itself. It is a precept open to current influences in art and design and has , in fact, been continually updated in drawing and print. Many styles of lettering design have been developed in the twentieth century in relation to advertising and display, which attempt to invoke particular associations with real objects or with an intended mood and feeling. In ornamental lettering, where the calligrapher can adapt forms to suit the pen stroke or move beyond the basic stroke to the intricacies of built-up letters, there are many clues on colour, form and texture to be gained from contemporary graphic design, as well as from the traditional excellence and sheer vitality of earlier forms.

Professional calligraphers will often be required to produce a distinctive letterform to a brief. The style of lettering in this rough (above) has become so closely associated with advertisements for Coca-Cola that it may even be misread. For assignments of a commercial nature, it is essential to be aware of such preconceptions in the public mind. Designing to a brief can be much harder than it appears.

A double-page spread can be arranged in a number of suitable forms (right). A page divided into two columns aligned at either side (1) is useful in newspapers or magazines, where small pictures may be inserted into the width of one column. Alternatively, two columns of text may be arranged around a central piece of ornamental writing or illustration (2). The standard double-page layout is placed with each outside margin equal to the central space between the blocks of text (3). This single page (far right) shows the balance of a standard type page, with three sides equal and more space at the bottom.

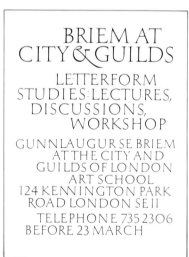

BRIEM AT CITY & GUILDS

LETTERFORM
STUDIES: LECTURES,
DISCUSSIONS,
WORKSHOP

GUNNLAUGUR SE BRIEM
AT THE CITY AND
GUILDS OF LONDON
ART SCHOOL
124 KENNINGTON PARK
ROAD LONDON SE 11

TELEPHONE 735 2306
BEFORE 23 MARCH

This hand-written poster (above) has a most unorthodox layout, since there is virtually no vertical alignment of the successive lines. Their shifts from centre give a spacious and lively arrangement and the proportions and spaces of the letters are extremely well balanced. As a result, the poster is eye-catching, aesthetically pleasing and easily legible.

Layout

The arrangement of writing on a page takes account of a number of variables in design. The proportions of white space to text — most simply represented in the widths of top, side and bottom margins — are assessed in terms of both aesthetic preference and the function of the work. Work that is presented flat, whether or not it is framed, may have any size of margin from minimal to extremely broad. Usually the lower margin is the deepest and the side margins are equal. Calligraphers may, however, apply aesthetic preferences. A freely written, flamboyant word or phrase may seem more expansive and rhythmic if generously surrounded by white space, whereas small, fine writing in an open letterform may gain cohesiveness if allowed to create a mass of text that is both broad and deep across the page.

Legibility is normally an important consideration. Between eight and twelve words per line are easily read. The number of words accommodated obviously depends upon the style and size of the letterforms. Five or six words per column is a reasonable adjustment. If there are fewer words in a line the text starts to seem jumpy, and a line longer than 12 words is tiring to read. Paragraphs may be differentiated by extra line spacing between them or, as in typographic convention, by an indention of the two or three letter widths at the opening.

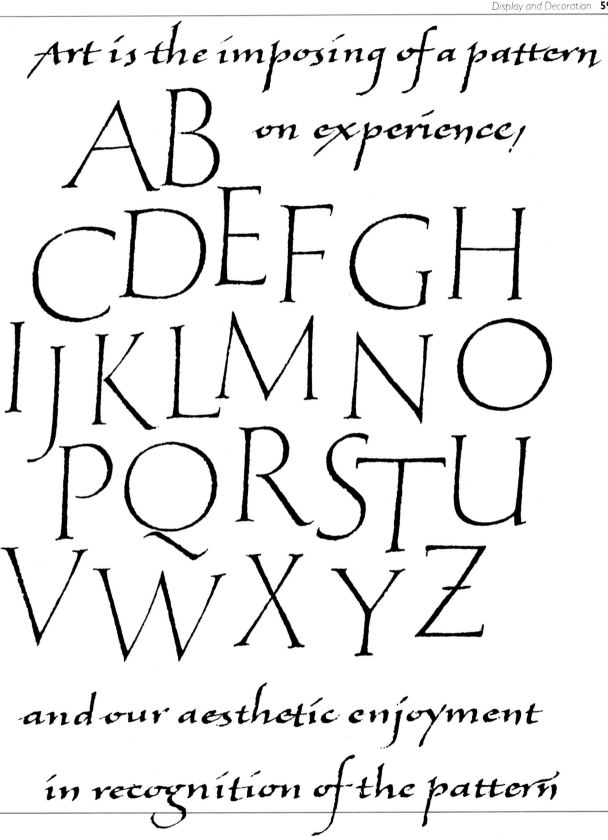

Art is the imposing of a pattern

on experience;

ABCDEFGH
IJKLMNO
PQRSTU
VWXYZ

and our aesthetic enjoyment

in recognition of the pattern

GLOSSARY

Arch The part of a LOWER-CASE letter formed by a curve springing from the STEM of a letter, as in h, m, n.

Ascender The rising stroke of a LOWER-CASE letter.

Base line Also called the writing line, this is the level on which a line of writing rests, giving a fixed reference for the relative heights of letters and the drop of the DESCENDERS.

Body height The height of the basic form of a LOWER-CASE letter, not including the extra length of ASCENDERS or DESCENDERS.

Book hand Any style of alphabet commonly used in book production before the age of printing.

Bowl The part of a letter formed by curved strokes attaching to the main STEM and enclosing a COUNTER, as in R, P, a, b.

Built-up letters Letters formed by drawing rather than writing, or having modifications to the basic form of the structural pen strokes.

Carolingian script The first standard MINUSCULE script, devised by Alcuin of York under the direction of the Emperor Charlemagne at the end of the eighth century.

Chancery cursive A form of ITALIC script used by the scribes of the papal Chancery in Renaissance Italy, also known as *cancellaresca*.

Character A typographic term to describe any letter, punctuation mark or symbol commonly used in typesetting; Chinese or Japanese ideogram.

Counter The space within a letter wholly or partially enclosed by the lines of the letterform, within the BOWL of P, for example.

Cross-stroke A horizontal stroke essential to the SKELETON form of a letter as in E, F, T.

Cuneiform The earliest systematic form of writing, taking its name from the wedge-shaped strokes made when inscribing on soft clay. *Cuneus* is a Latin word meaning 'wedge'.

Cursive The description of a handwriting form that is rapid and informal, where letters are fluidly formed and jointed, without pen lifts.

Demotic script The informal SCRIPT of the Egyptians, following on from HIEROGLYPHS and HIERATIC SCRIPT

Descender The tail of a LOWER-CASE letter that drops below the BASE LINE.

Diacritical sign An accent or mark that indicates particular pronunciation of a letter or syllable.

Face abb **Typeface** The general term for an alphabet designed for typographic use.

Flourish An extended pen stroke or linear decoration used to embellish a basic letterform.

Gesso A smooth mixture of plaster and white lead bound in gum, which can be reduced to a liquid medium for writing or painting. It dries hard and is used in creating a raised letter for GILDING.

Gilding Applying gold leaf to an adhesive base to decorate a letter or ORNAMENT.

Gothic script A broad term embracing a number of different styles of writing, characteristically angular and heavy, of the late medieval period.

Hand An alternative term for handwriting or SCRIPT, meaning lettering written by hand.

Hairline The finest strokes of a pen, often used to create SERIFS and other finishing strokes, or decoration of a basic letterform.

Hieratic script The formal SCRIPT of the ancient Egyptians.

Hieroglyphs The earliest form of writing used by the ancient Egyptians, in which words were represented by pictorial symbols.

Ideogram A written symbol representing a concept or abstract idea rather than an actual object.

Illumination The decoration of a MANUSCRIPT with gold leaf burnished to a high shine; the term is also used more broadly to describe decoration in gold and colours.

Indent To leave space additional to the usual margin when beginning a line of writing, as in the opening of a paragraph.

Italic Slanted forms of writing with curving letters based on an elliptical rather than circular model.

Layout The basic plan of a two-dimensional design, showing spacing,

organization of text, illustration and so on.

Lower-case Typopgraphic term for 'small' letters as distinct from capitals, which are known in typography as upper-case.

Majuscule A capital letter.

Manuscript A term used specifically for a book or document written by hand rather than printed.

Massed text Text written in a heavy or compressed SCRIPT and with narrow spacing between words and lines.

Minuscule A 'small' or LOWER–CASE letter.

Ornament A device or pattern used to decorate a handwritten or printed text.

Papyrus The earliest form of paper, a coarse material made by hammering together strips of fibre from the stem of the papyrus plant.

Parchment Writing material prepared from the inner layer of a split sheepskin.

Pictogram A pictorial symbol representing a particular object or image.

Pounce A fine powder used to prevent ink from spreading on unsized paper and to prepare the surface of parchment to receive ink.

Ragged text A page or column of writing with lines of different lengths, aligned at one side only or on a central axis.

Roman capitals The formal alphabet of capital letters, devised by the Romans, which was the basis of most modern, western alphabet systems.

Rustic capitals An informal alphabet of capital letters used by the Romans, with letters elongated and rounded compared to the standard square ROMAN CAPITALS.

Sans-serif A term denoting letters without SERIFS or finishing strokes.

Script Another term for writing by hand, often used to imply a CURSIVE style of writing.

Serif An abbreviated pen stroke or device used to finish the main stroke of a letterform; a hairline or hook, for example.

Skeleton letter The most basic form of a letter demonstrating its essential distinguishing characteristics.

Stele An upright slab or pillar carrying an inscription.

Stem The main vertical stroke in a letterform.

Textura A term for particular forms of GOTHIC SCRIPT that were so dense and regular as to appear to have a woven texture. *Textura* is a Latin word, meaning 'woven'.

Uncial A BOOK HAND used by the Romans and early Christians, typified by the heavy, squat form of the rounded O.

Vellum Writing material prepared from the skin of a calf, having a particularly smooth, velvety texture.

Versal A large, decorative letter used to mark the opening of a line, paragraph or verse in a MANUSCRIPT.

Weight A measurement of the relative size and thickness of a pen letter, expressed by the relationship of nib width to height.

INDEX

*Page numbers in **bold** refer to captions and illustrations*

ACKNOWLEDGEMENTS

The photographs on these pages were reproduced by kind courtesy of the following:
2 Herman Zapf; **6** Michael Holford; **7** Ronald Sheridan's Photo-Library; **8** Lettering Archive, Central School of Art; **9** Ronald Sheridan's Photo-Library; **10** Paul Arthur; **11** (1, 2, 4) Paul Arthur; (3) The Trustees of the British Museum; (5) Ronald Sheridan's Photo-Library; **12** Ronald Sheridan's Photo-Library; **13** British Library; **14** Koyama Tenshu; **15** (1, 4) British Library; (2, 3) Bodleian Library, Oxford; (5) Ronald Sheridan's Photo-Library; **16** (t) British Library; (b) V & A Photographic Library; **17** (tl) Karlgeorg Hoefer; (tr) Donald Jackson; (b) Hella Basu; **18-21** Quill; **22** Arthur Baker; **23** (t) Heather Child/Dorothy Mahoney; (b) Miriam Stribley; **24-25** Quill; **28** Merilyn Moss; **29** (l) Imre Reiner; (r) Peter Thompson; **32** Paul Arthur; **33** Werner Schneider; **34** Dover Publications, Inc; **35** Lettering Archive, Central School of Art; **36-37** (t) Dover Publications, Inc; **36** (c, b) Miriam Stribley; **37** (b) V & A Photographic Library; **38** Dover Publications, Inc; **39** Carol Thomas; **40** (l, r, b) Quill; (c) Dover Publications, Inc; **41** The Fotomas Index; **42** (t) Miriam Stribley; (b) Heather Child; **43** Dover Publications, Inc; **44** (l) V & A Photographic Library; (r) Dover Publications, Inc; **45** The Fotomas Index; **46-47** Quill; **48** (l) V & A Photographic Library; (r) The Fotomas Index; (b) Dover Publications, Inc; **49** Quill; **50** (l) The Fotomas Index; (r) British Library; **51** Gunnlaugur SE Briem; **52** (t) Hans Schmidt; (b) Jovica Veljovic; **53** Terry Paul; **55** Jagjeet Chaggar.

KEY: (t) top; (b) below; (l) left; (r) right; (c) centre

While every effort has been made to acknowledge all copyright holders, we apologize if any omissions have been made.